IMAGES
of America

POWNAL

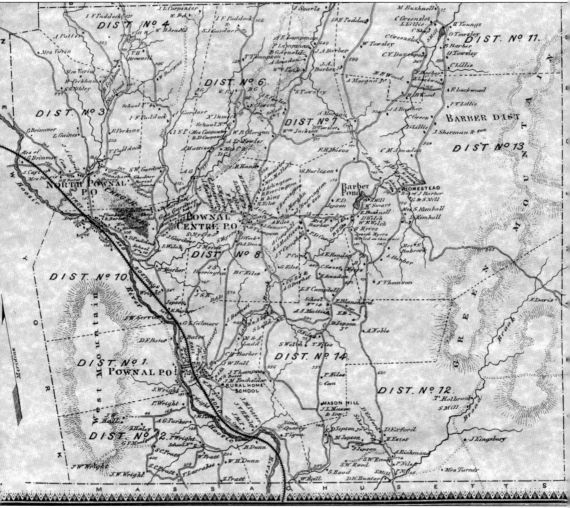

Slightly more than 100 years after Benning Wentworth granted the charter creating Pownal, this 1869 F. W. Beers map captures Pownal's farms and businesses at a time when their prosperity was equivalent to many towns in Vermont. The Hoosic River flows from the western margin to the southern margin, passing the towns of North Pownal and Pownal. Pownal Center is near the center of the map. (Courtesy of F. W. Beers, *Atlas of Bennington County, Vermont.*)

ON THE COVER: In 1822, Augustus Weatherwax and John M. Potter converted a 1782 building into this store. Potter ran the store with Abram B. Parker and then sold it to Oscar D. and Emma Card. When manager George Bigert installed a switchboard, or "central," Carolyn Wollschleger became its operator. First her husband, Paul Wollschleger, and then Joseph Proud were the managers. Before it was razed in 1943, children called this the "gum store." (Courtesy of Jeanne Quinn.)

IMAGES
of America

POWNAL

Pownal Historical Society

ARCADIA
PUBLISHING

Published by Arcadia Publishing
Charleston SC, Chicago IL, Portsmouth NH, San Francisco CA

Printed in the United States of America

Library of Congress Control Number: 2009934371

For all general information contact Arcadia Publishing at:
Telephone 843-853-2070
Fax 843-853-0044
E-mail sales@arcadiapublishing.com
For customer service and orders:
Toll-Free 1-888-313-2665

Visit us on the Internet at www.arcadiapublishing.com

CONTENTS

ACKNOWLEDGMENTS

For her many days of work converting, storing, and rearranging photographs into our digital archive, we thank Dawn Rodrigues. For their technical assistance in making photographs accessible, we thank Gudrun Hutchins, Carl Villanueva, and Robert Washburne. For advice and help when needed, we thank Linda Hall, Joe Hall, Ken Held, John and Georgie Holovach, Victor Rolando, and Jimmy Winchester.

For kindly donating photographs for us to use, we thank: Ted Atkinson, Keith Armstrong, Henry Bassen, Betsy Beals, Allison Bell, Jannette Bishop, Ron Bisson, Julia Bright, Rosemary Brown Estate, Ann Bugbee, Joy Bull, Sylvia Bull, Karen Burrington, Joan Cannell, Barbara Casey, Jane Chamay, Barbara Champney, Lois Comar, Melba Cooper Estate, Barbara Cota, Jean and Gary Dickson, Andy Dodge, James Gilbert, Pam Goodhue, Kinsley Goodrich, Maida Goodwin, Judy Greenawalt, Mabel Haley Estate, Gary Harbour, Rigby Helck, Marietta Hibbard, Sylvia Hill, Donna Ianni, Bill James, Hulda Jowett, April Knapp, Ronald Knapp, Dianne Lamb, Frances Lampman, Margaret Lillie, Bruce Lingner, Herbert Lorenz Estate, Carla Lund, Anson and Jacky Mason, Kenneth and Susanne Mason, Mary Louise and Warren Mason, Rachel Mason, Julia Maxmillian, Gertrude McIver, Harold McLenithan, Eleanor Murphy, Jeanne Overstreet, Dorothy Pizzano, Eve Pearce, John Pettibone, Anson Pratt, George Pratt, Sylvia Proud, Jeanne Quinn, Mary Jane Rounds, Richard Ryder, Helen Strobridge, James Therrien, and Georgene Villanueva.

We also want to thank the following institutions, organizations, and businesses for allowing us to use their images: *Bennington Banner*; Boston Public Library; Library of Congress; National Baseball Hall of Fame, Cooperstown, New York; Pownal Historical Society; Rensselaer Polytechnic Institute; Solomon Wright Library; Vermont Historical Society; *Vermont Life*; and Williams College.

For rapid responses to all our questions and for guiding us through the process, we appreciate the work of Hilary Zusman and the support of editor Tiffany Frary at Arcadia Publishing.

INTRODUCTION

"Pawnal ye first town, poor land—very unpleasant—very uneven—miserable set of inhabitants—no religion, Rhode Island haters of religion—Baptists, quakers, & some Presbyterians—no meeting house." So wrote the Reverend Nathan Perkins in 1796 as he began his tour of Vermont in Pownal. Of course, Perkins's opinion of Pownal was much like his opinion of the rest of Vermont.

If only Perkins had been able to carry a camera with him and had taken more time to learn what Pownal was like, he would have seen farms along the Hoosic River in Pownal that had been built in the 1720s by tenant farmers on the manor of Renssylaerwyck, establishing them as settlers long before any other Europeans settled western Vermont. He might have seen evidence of the Mahicans who farmed the valley and hunted the hills of Pownal centuries before the Europeans arrived.

Had he stayed for a while, he would have realized that Pownal was not without its conflicts, even in its early days, and others might have benefited from his insights. The governor of New Hampshire, Benning Wentworth, contributed to the disputes when he chartered Pownal on January 8, 1760, making Pownal one of the first chartered towns in Vermont. Newly arrived English settlers tried to evict earlier settlers. Though generally called "Dutch," the first settlers included Huguenots, Walloons, and Pallatines. Samuel Robinson came down from Bennington to arrest some earlier settlers and was himself detained. During the Revolution, loyalties divided Pownal citizens, and Patriots imprisoned a number of Tories, or Loyalists. Men from Pownal joined the Green Mountain Boys. Tories and Patriots from Pownal fought each other at the Battle of Bennington or Walloomscoick and participated in other battles of the war. After the war, families like the DeVoets, Bucks, Andersons, and Walkers, their property confiscated, fled to Canada. Some Green Mountain Boys, like Samuel Poppleton, went west.

Early photographs begin with some rare daguerreotypes from the 1840s and then move rapidly past the Civil War. Far more gravestones than photographs commemorate the men who fought in that war, unfortunately. As in much of Vermont, many soldiers returned home to their hill farms, realized how depleted the soil had become, and left for more fertile lands they had seen during the war. One, Merritt Barber, went on to a successful military career. Those soldiers who remained often used their experience with cavalry horses or knowledge acquired near battlefields to help them survive on their farms or in support services for the mills and the quarries established in the towns. Families who stayed struggled to make their hill farms produce, experimenting with Merino sheep, cattle, pigs, and poultry when the hill soils could not produce enough to eat, often logging the remaining trees to feed the mills or to construct new homes. In the river bottoms and in the "sugar bush," agricultural efforts flourished. Sons and daughters went off to further education in nearby towns such as Bennington, Williamstown, and North Adams, Massachusetts, returning to teach, start businesses, and continue their families' work or leaving to establish new lives.

Following the Civil War, photographs of early Pownal begin to proliferate, as the early woolen mills, cotton mills, and limestone quarries brought new workers and more money to Pownal's

people. Two future U.S. presidents, Chester Allen Arthur and James Garfield, taught in North Pownal. Jim Fisk, born here, went on to become an early financial baron. George Westinghouse visited his grandfather's farm. Emigrants from French Canada and elsewhere sweated to survive in the woolen mills first and then the cotton mills. Photographer Lewis Hine captured young mill workers in North Pownal as he traveled the country documenting child labor practices and abuses. His photograph taken of one girl, Addie Card, was used on a U.S. postage stamp commemorating the passage of the first child labor laws. Grace Greylock Niles became the first historian of Pownal, publishing *The Hoosac Valley* and *Bog Trotting for Orchids*. An art colony existed here from the 1920s through the 1950s and included the modernist Teng Chiu.

Beginning in the late 1880s and especially after World War I, more affordable cameras produced photographs of Pownal folks going about their daily lives: a family reads in its parlor, children line up for school, a young husband helps his wife hang clothing, a man poses in his new horseless carriage and later in front of his automobile business, Catholic children dress for their First Communion, owners of general stores stand on their porches with customers and friends, a Civil War veteran stands proudly next to his horse, a young woman visiting friends on a local farm drinks from a horse trough, a boy rides in a goat wagon, young girls and boys hike out along a mountain ridge, and a woman measures hides in the tannery.

If one theme emerges from these images of Pownal's past, it is that the people of Pownal—early settlers, more recent immigrants, and those here today—have worked very hard over the years. Images of young workers in bare feet, just entering their teens, and students without shoes remind us that life in Pownal has not been easy. Resting farmers standing in the field with their potato crop reflect their pride in work well done. The driver of a milk wagon, the driver of a mail wagon, and the farmer standing by a lumber truck illustrate the daily efforts that enabled others to enjoy their lives. And those who went off to World War II and never returned are memorialized on the cover of a town meeting annual report.

Not only daily struggles, but also celebrations appear in the photographs: a large crowd gathers with flags on Memorial Day, the town celebrates the nation's bicentennial with reenactments and dedications, and a wagon train beginning in Pownal recognizes the state's bicentennial by travelling throughout Vermont. An early baseball team, a 1960s go-cart track, and a horse and greyhound racetrack that eventually failed illustrate how folks in Pownal played in their spare time, if only momentarily.

Later photographers saw in Pownal the beauty and peace they associated with rural life, accurately or stereotypically. *Post*, *Vermont Life*, and even an early United Nations (U.N.) publication all featured views of Pownal on their covers. *Vermont Life* once called the view from Carpenter Hill in Pownal the most beautiful view in Vermont. In the U.N. photograph, taken after World War II, Pownal symbolized the peace that organization dreamed of creating.

Today, as tourists travel from the Berkshires south of Pownal, from the Hudson River valley to the west, or in buses from cities like New York, they too, like Rev. Nathan Perkins, experience Vermont for the first time by entering Pownal. Today, the Green Mountains to the east and the Taconic Range to the west frame the valley of the Hoosic and the towns of Pownal, North Pownal, and Pownal Center, as well as the East Pownal area, just as they framed them in these photographs from the past, helping us to remember that past and to recognize the efforts of those who have come and gone before us.

Raymond J. Rodrigues
Charlotte Comar
Wendy Hopkins
Pownal, 2010

One

POWNAL ACROSS TIME

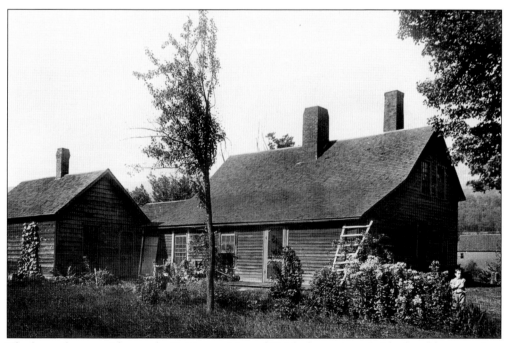

The house known either as the DeVoet or Mooar/Wright house is probably the oldest complete house in Pownal and possibly Vermont's oldest. Jan Ernst DeVoet, the most likely builder, settled in Pownal before the American Revolution. A Tory, he was imprisoned during the Revolution, escaped, fought against the Patriots, was captured at the Battle of Bennington, escaped again, and fled to Canada as a Loyalist. (Courtesy of Jean and Gary Dickson.)

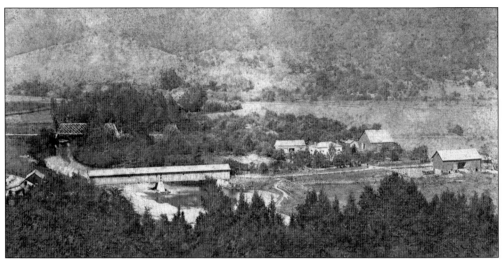

The farm photographed here around 1900 was originally the Vosburgh farm. Petrus Vosburgh was a tenant farmer on the manor of Renssylaerwyck. The long covered bridge across the Hoosic River is gone, but the railroad bridge beyond it remains. The large barn second from the right dated back to the 1740s before it was torn down in the last half of the 20th century. (Courtesy of Jim Gilbert.)

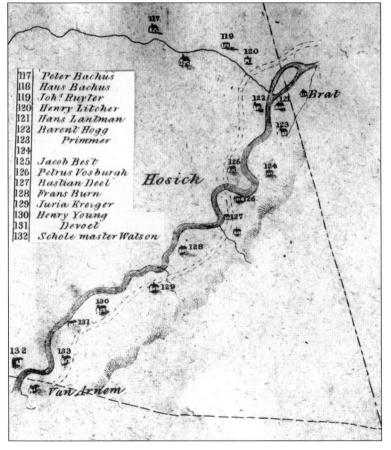

"A Map of the Manor of Renselaerwyck," created in 1767 by surveyor John R. Bleeker, included Pownal in its northeast corner. Bleeker lists the families, some of whom may have occupied the land in the 1720s. Farm No. 121 is the DeVoet or Mooar/Wright house in Pownal, shown on page 9. Farm No. 126 is the Vosburgh farm show above. (Courtesy of Institute Archives and Special Collections, Rensselaer Polytechnic Institute.)

James C. Angell (1831–1887) was born in Pownal, the son of Samuel Angell of Pownal and Ryanna Rosenburg of North Petersburg, New York, and grandson of Revolutionary War captain Abiathar Angell. When his father died, his mother remarried Josiah Bates of Pownal. Photographed in 1853, Angell married and then became the publisher of the *Hoosac Valley News* and, with Aaron Hardman, the *North Adams Transcript*. (Courtesy of Hulda Jowett.)

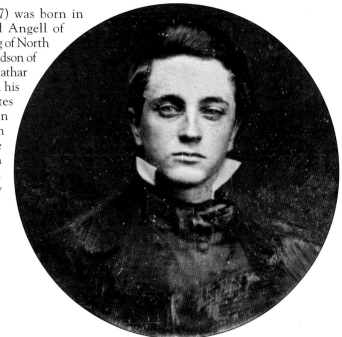

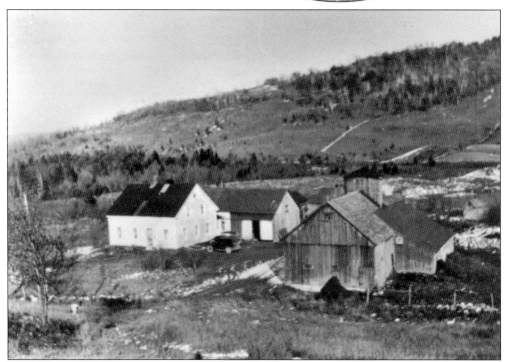

The Perry Thompson farm, later the Barber farm, dates back to the late 1700s. In the early 1900s, hunting and fishing "camps," or cabin sites, grew popular in Pownal, and this farm was purchased by the Vermont Outing Club. Now known as Verdmont, both summer and full-time residents live here. The open fields on the distant mountain called "the Dome" have now grown back into woods. (Courtesy of Ann Bugbee.)

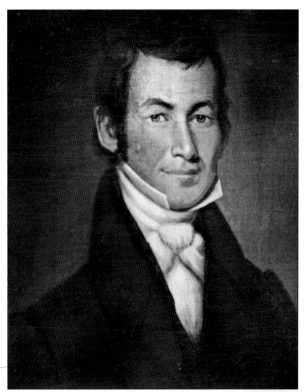

Thomas Bannister (1759–1824) became a doctor in Pownal after the Revolutionary War. When his first wife, Susee Lincoln, died, he married Lydia Dunham Downer. Bannister served as town treasurer, justice of the peace, and town clerk. He and his family raised sheep, carded the wool, and made blankets. His descendants own silver teaspoons made from his Revolutionary War buttons and sword hilt. (Courtesy of Julia Ransford Bright and Robert Washburne.)

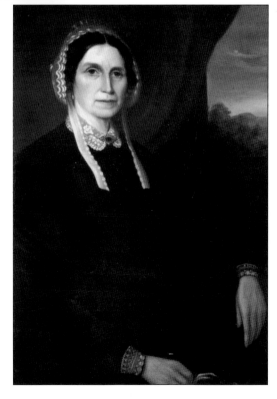

Hannah Niles Carpenter (1799–1862) married Reynolds Carpenter after her sister, Mary Polly Niles, the first wife of Reynolds Carpenter, died during childbirth in 1822. Hannah gave birth to seven children and was stepmother to six. Carpenter Hill in Pownal is named after this family. (Courtesy of Jane Chamay.)

Lydia Dunham Downer Bannister (1785–1861) was the daughter of John and Lydia Dunham Downer of Pownal. She lived her entire life in Pownal Center and, after marrying Thomas Bannister in 1814, had six children. Her father, John Downer, served in the Revolutionary War, as did her grandfather, Obadiah Dunham. She and her husband are both buried in Pownal Center. (Courtesy of Catharine Rigby Helck and Robert Washburne.)

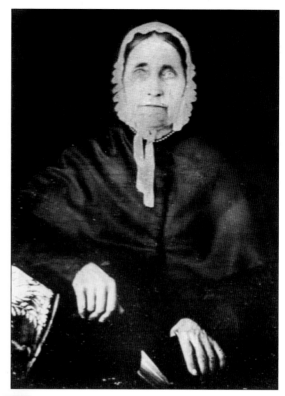

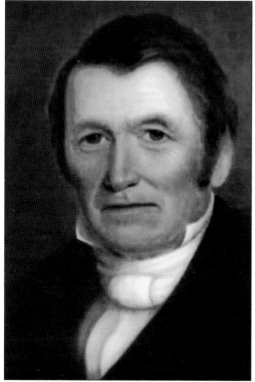

Reynolds Carpenter (1784–1862) was elected to the state legislature in 1833 and worked to protect local farmers and manufacturers, particularly wool farmers and mill owners, from what they perceived as exorbitant taxation by the government, which favored importations. He first married Mary Niles and then her sister Hannah Niles, fathering 13 children. (Courtesy of Ted Atkinson.)

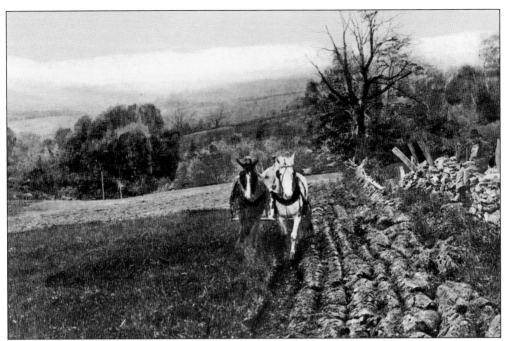

Ammon Fowler, sitting on the wall, watches his son Loren plowing their farm on Carpenter Hill around 1900. Stripped of their trees for lumber, mill fuel, and potash, the hills had little good soil by the time of the Civil War. Hill farmers struggled to grow crops and feed their animals, so returning Civil War veterans led an exodus from the state in search of better lands. (Courtesy of Rachel Mason.)

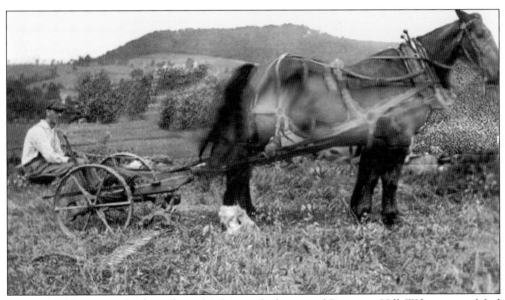

Lauriston Wilcox sits on his hay rake on his farm at the bottom of Carpenter Hill. Wilcox exemplified many of the farmers of Pownal: involved in the community, hardworking, and knowledgeable. Wilcox, who had married a Gardner, saved the Gardner Cemetery from disrepair by trimming wild plant growth and righting tombstones. (Courtesy of Sylvia Proud.)

Margaret A. Carpenter (1829–1914) was a daughter of Reynolds and Hannah Niles Carpenter who never married. Born and raised on Carpenter Hill between Pownal Center and Bennington, she lived the latter part of her life in North Petersburg, New York. (Courtesy of Jane Chamay.)

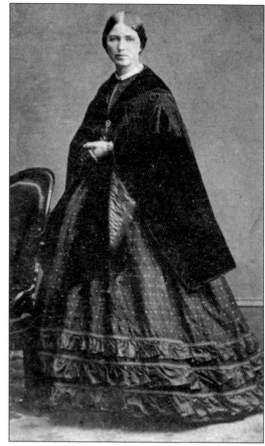

Through the years, the road from Pownal Center down into North Pownal has had many names: Dark Woods Road, Lime Kiln Road, North Pownal Road, and even Select Road. The large house on the left was once Lime Kiln House, part of the nearby lime kiln operations. A large lime quarry site can still be seen in the hill near the right of the photograph. (Courtesy of Ron Bisson.)

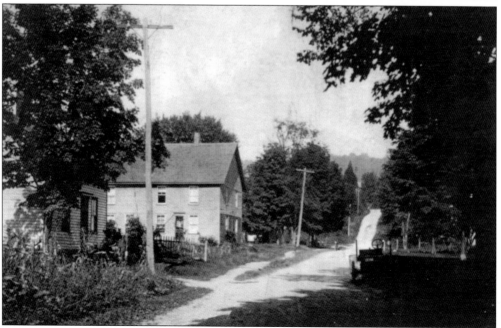

In 1880, Child's Bennington County Directory reported that North Pownal had two railroads, a Congregational church, a hotel, three stores, a post office, a wagon shop, a gristmill, a cheese factory, and a saloon. The North Pownal Manufacturing Company cotton mill, owned by A. C. Houghton and Company, was the largest employer, with about 230 employees. With approximately 16,000 spindles, it produced roughly 5 million yards of cotton cloth annually. T. V. McCumber

owned the North Pownal Saw Mill, cutting about 30,000 feet of lumber annually. H. Burden and Sons owned the limestone quarry and shipped the product to their iron works in Troy, New York. By the time of World War I, approximately when this photograph of the main street through North Pownal was taken, the town was doing quite well. (Courtesy of Carla Lund.)

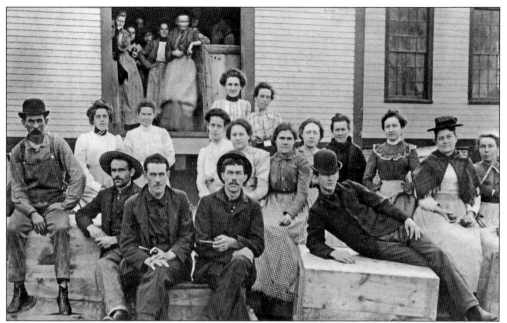

Mills provided crucial employment after the Civil War. Here in Pownal village, workers pose at the Hoosic Valley Mill, originally the Solomon Wright Mill, around 1900. This woolen mill was built in 1863 in part to meet the clothing demand created by the Civil War. Later products included yarn and hosiery. About 40 people worked here at its peak. The mill burned down in 1905. (Courtesy of Sylvia Proud.)

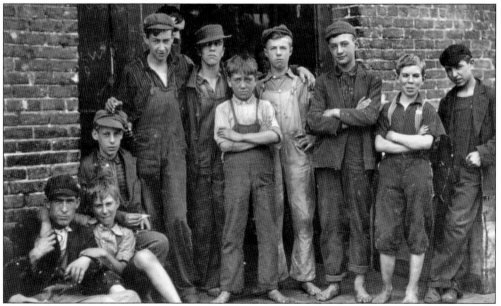

Young children often worked in the North Pownal mill. Lewis Hine's caption on this photograph from August 1910 identifies "David Noel, 14; Theodore Momeady, 15, working three years; Albert Sylvester, 13, working one year; Eugene Willette, 13, working one year; Arthur Noel, 15, working one year; P. Tetro, 15, working one year; T. King, 14, working one year. Clarence Noel, 11, working one year." (Courtesy of the Library of Congress.)

The cotton mill was converted into a tannery that was fined by the Environmental Protection Agency in 1981 for violating pollution standards. In 1988, the company filed for bankruptcy, and the building was torn down after being designated a Superfund site. In this view, a truck prepares to haul "fleshings," flesh and fur scraped from the hides and made into products like gelatin. (Courtesy of the *Bennington Banner*.)

Most people farmed one way or another before World War I, even using goats for various tasks. Roy Lampman (left) and Ed Lampman (right), with an unidentified friend, complete their chores with the help of their goats pulling a load of hay. The dog Spot takes it easy. Behind them on the right is the Pownal Center School. Roy later became the first auto dealer in Pownal. (Courtesy of Fran Lampman.)

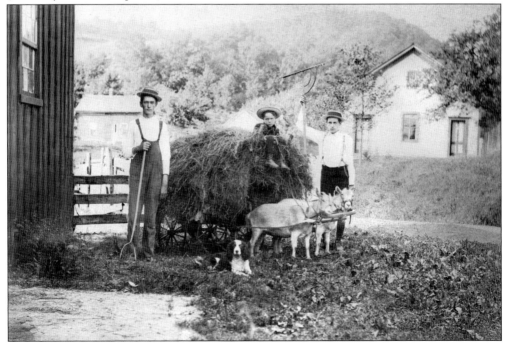

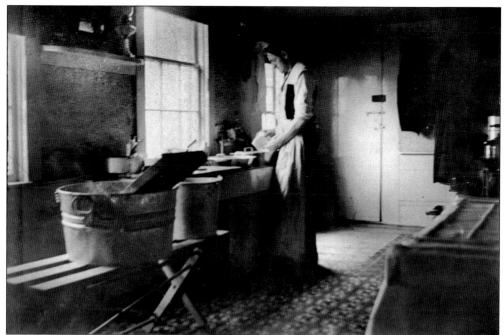

Defying stereotypes of what men did and did not do in the early days, Roy Lampman does the washing with everything lined up: wash bucket with the washboard, rinsing bucket, and then a level place for ironing after the clothes dry on the line. Boil water, boil the dirtiest clothes, dip in soapy water, rub on the washboard, rinse, wring out, hang on the line, and repeat. (Courtesy of Fran Lampman.)

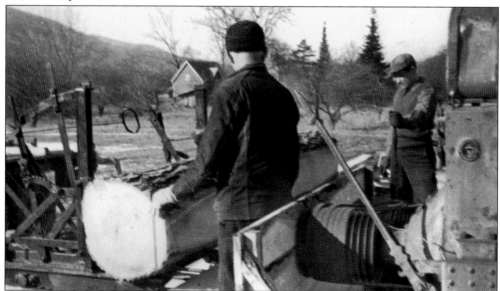

Vincent Pizzano (right) and an unidentified man saw the first log as Northeast Wood Products opens in 1946. With his partner, Siegfied "Fritz" Tolle, he renewed a traditional industry in Pownal, logging and a sawmill. Employing about 25 loggers, truckers, and a secretary, they donated lumber to town projects like the library and sold ash wood to Louisville Slugger for baseball bats. (Courtesy of Dorothy Pizzano.)

Two

POWNAL CENTER
AND EAST POWNAL

Pownal Center, photographed by Gustav Anderson, was selected by the United Nations (U.N.) as "a picture of peace" following World War II. This picture was shared with the world on the cover of the U.N.'s *Weekly Bulletin* of September 30, 1946. Little has changed. Dramatic views extend south and west across the Hoosic River valley. Many of the buildings date from before 1850. In 2009, the Vermont Advisory Council on Historic Preservation recognized the Pownal Center Historic District on the State Register of Historic Places. (Courtesy of Chamberlain and Moffat, *Fair Is Our Land*.)

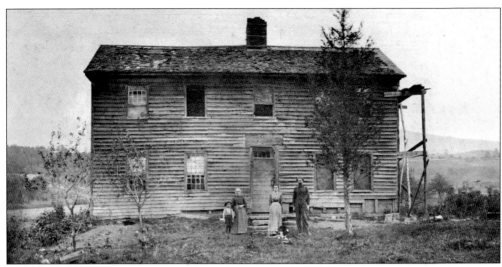

The Mallory House, also known as the Munson Tavern, stood near the road leading to Pownal Elementary School. Built as a hotel by Timothy Munson around 1788, it also served as headquarters for a horse company that drilled there before and during the War of 1812. Many units of the Massachusetts militia, travelling to and from Bennington, stopped there. The building was torn down around 1908. (Courtesy of Ray Rodrigues.)

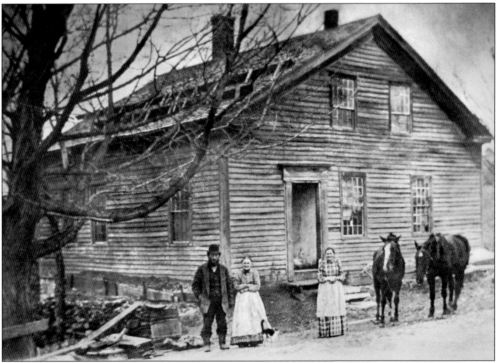

This house on Center Street dates to before 1800 and was once the home of Dr. Thomas Bannister and Lydia Downer Bannister, who may be pictured here. They were married on March 10, 1814, and had five children—Thomas, Susan, Charles, Lucy, and Almira. Note the work being done on the south-facing roof. According to local lore, the basement was once used as a jail. (Courtesy of John Pettibone.)

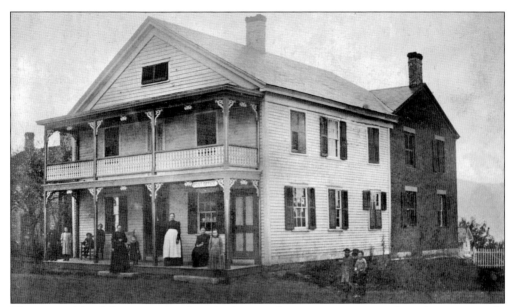

The original brick house at rear dates back more than two centuries and was known in early records as "The Tavern" and "The Tavern Stand." Standing on the 1880s porch in a white apron is Mary Frances Towslee Kimball Lampman. The house has been owned since the mid-1800s by seven generations of Lampmans and has housed the post office, the town clerk's office, a general store, a garage office, and a realty office. (Courtesy of Frances Lampman.)

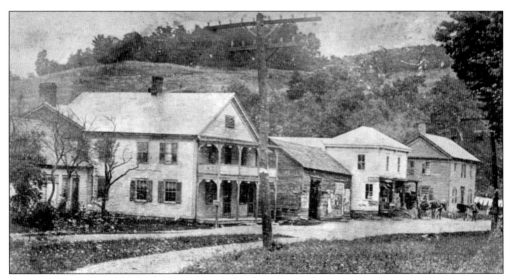

Pownal Center in 1890 looked much as it had a century before. Cars have yet to appear, the street is still dirt, and Roy Lampman's auto garage has yet to move into the blacksmith shop in the center of this picture. This was the main road from Bennington to Massachusetts; to go to North Pownal, the road passed between the two-story hotel and the blacksmith shop. (Courtesy of Frances Lampman.)

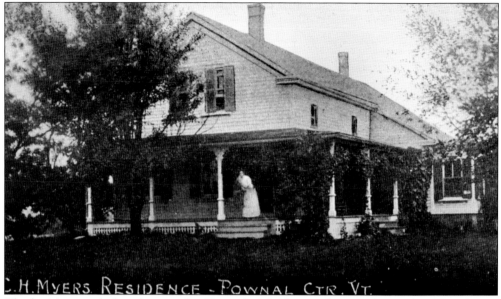

Charles Myers took this photograph of his wife, Myrtle, standing on the porch of their home. In later years, the home provided an office for the town clerk who lived there, housed artists taking part in the local art colony, and stood out in its location next to the cemetery. (Courtesy of Gertrude McIver.)

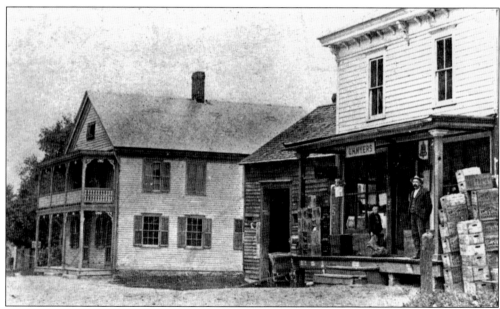

This property on Center Street in the late 1800s was Charles H. Myers' Store, selling dry goods and groceries, including the popular drink Moxie. The Pownal Grange held meetings on the second floor, which was also used as a dance hall. An antique shop opened there in 1963 on the same day that Pres. John F. Kennedy was assassinated. The property currently houses a workshop for a women's antique clothing business. (Courtesy of Jane Chamay.)

The Pownal Center Community Church was featured on the cover of *Vermont Life* magazine in the autumn of 1960. Originally the Union Church, it was founded in 1794 by the Baptist Society. The present building was constructed in 1849 over the original meetinghouse and was "open to established denominations of Pownal in the true spirit of freedom of worship." The main road from Bennington to Williamstown ran in front of the church before Route 7 was constructed. The lower level of the building was used by the Town of Pownal for town meetings and voting until March 1991. The original wooden voting booths remain. Below, town clerk Rachel Mason, who served from 1955 to 1990, delivers the official "warning," or advance notification, of the upcoming voting in the basement of the church in 1961. Her daughter Connie looks on. (Right, courtesy of *Vermont Life* magazine; below, courtesy of Rachel Mason.)

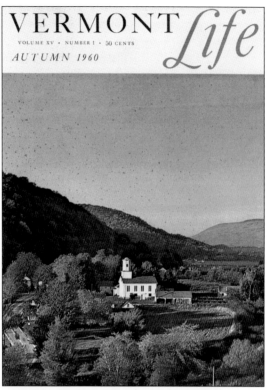

VERMONT *Life*

VOLUME XV · NUMBER 1 · 50 CENTS

AUTUMN 1960

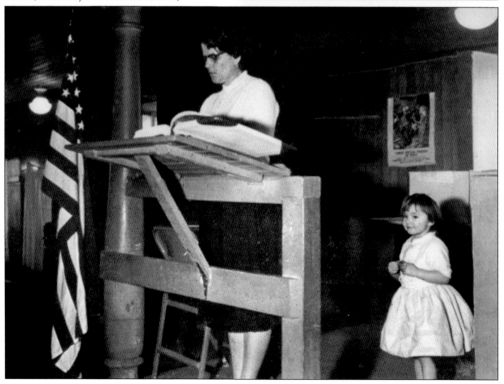

Mountain View Inn, also known as Bartels Lodge and shown here in 1944, sits at the former crossroads of Barber Pond Road and Old Route 7 (Center Street). It was long a summer headquarters to artists, including the Arts Students League of New York, which came to Pownal to paint the beautiful valley en plein air. Students and faculty boarded at the inn and in area homes. (Courtesy of Mary Jane Rounds.)

The artist Teng Chiu (far right), seen here with, from left to right, Jane Mason Barker, Irene Dean Mason, and Ruth Mason Riall, has been rediscovered as China's first modern painter. He was active in the art colony in Pownal, painting many vibrant scenes here. Born on Gulangyu Island in China, he studied art in the United States and travelled the world; truly an artist without borders. (Courtesy of Anson and Jackie Mason.)

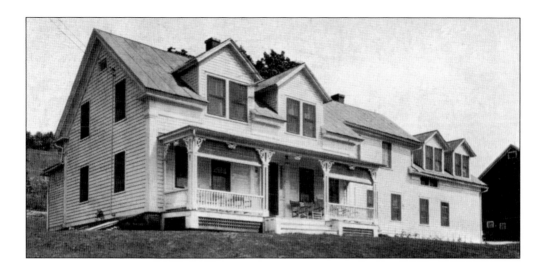

Grandview Farm, seen above in 1939, was a popular destination for tourists. The name reflects the enormous view to the south and west that encompasses almost half of Pownal's 46.7 square miles. For many years, it was known as the Grandview Farm Guest House and was run by Danny Mason, a fifth-generation farmer, and his wife, Shirley. The sweeping vista long attracted artists. Below, an artist paints the view to the southwest from the hills east of Pownal Center, just down the hill from the Grandview farmhouse. (Both, courtesy of Donna Ianni.)

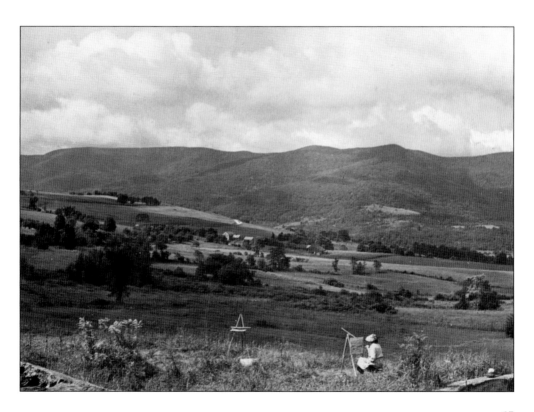

Esther Niles assists Andrew Crosier as he pours "sugar" (maple syrup) on snow for friends at the Pownal Center Fire House on July 6, 1958. Crosier stored snow in his freezer during the winter and opened it up for his annual "sugar eat" party in the summer to raise money for the Pownal Center Fire House. Crosier also served as a town selectman for nine years. (Courtesy of Charlotte Comar.)

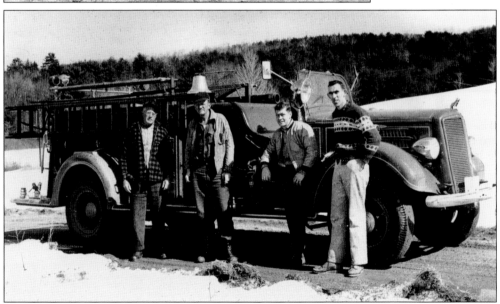

From left to right, firemen Floyd Patterson, Ned Towslee, Red Chenaille, and Ernie Roberts stand in front of their fire truck in the 1950s. Pownal Center had a fire truck but no firehouse; the truck was housed in John Patterson Sr.'s garage until the firehouse was built between 1956 and 1958. Today there are four fire stations in Pownal and one rescue squad serving 3,600 residents. (Courtesy of Pam Goodhue.)

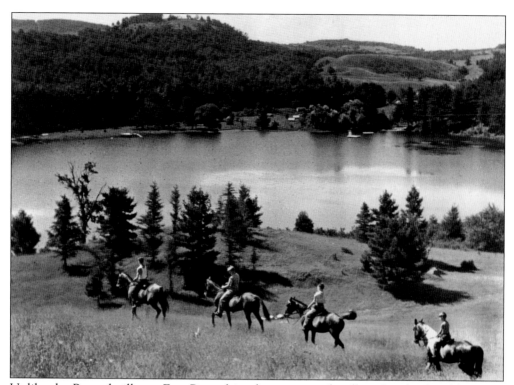

Unlike the Pownal villages, East Pownal is a large area with rolling farmland and beautiful vistas. In this picture, taken around 1940, after breakfast and chapel, a group of campers at Kamp Kaaterskill on Barber (Perch) Pond go horseback riding. The view to the east shows the sweep of open meadows and mountains. Today the land has been taken over by trees. (Courtesy of Herbert Lorenz Estate.)

Wilhelm Strohmaier applies lime to one of his fields in East Pownal. Strohmaier was the Vermont recipient of the New England Green Pastures Award in 1952–1953. Every year, a Vermont farm is chosen that represents superior achievement in dairy herd management, land stewardship, and contributions to the agricultural field and community. (Courtesy of Dianne Lamb.)

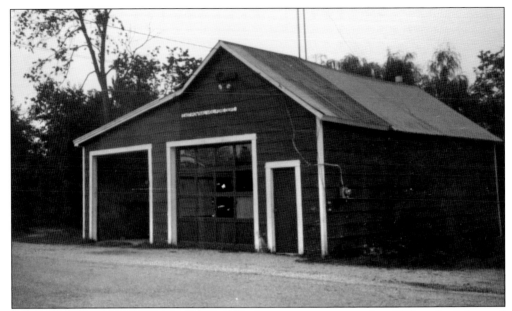

The first building used by the East Pownal Firehouse was constructed in 1970 on land donated by Clyde Lanfair on the condition that the title would revert to him or his heirs if it was not used for a firehouse. Subsequently a bigger and better firehouse was built on the site. East Pownal's firefighting service merged with its Pownal Center and North Pownal counterparts in 1994 to create the Pownal Valley Fire Department. (Courtesy of April Knapp.)

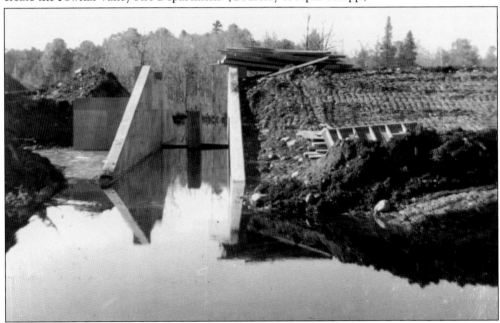

The Vermont Fish and Wildlife Department created the South Stream Fish and Wildlife Area in East Pownal in 1959. The South Stream ran through a swamp. Here the dam is under construction and almost completed. At this writing, the Nature Conservancy is interested in acquiring additional land around the wildlife area to protect the surrounding environment. (Courtesy of Charlotte Comar.)

Three

POWNAL VILLAGE

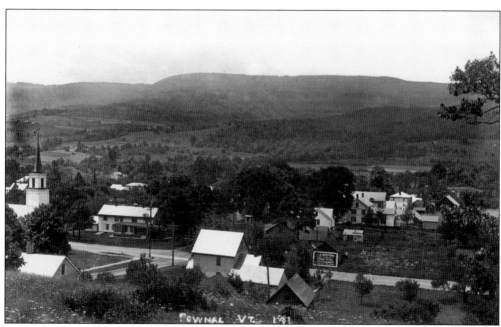

In this view of Pownal village, taken in 1941, the steeple of the Pownal United Methodist Church is visible on the left, and a billboard can be seen in lower right on the current Route 346. Beyond, the Taconic Range rises to the west. The church burned in 1980, and billboards were banned from Vermont highways in the 1960s, the result of the Highway Beautification Act of 1965. (Courtesy of the Pownal Historical Society.)

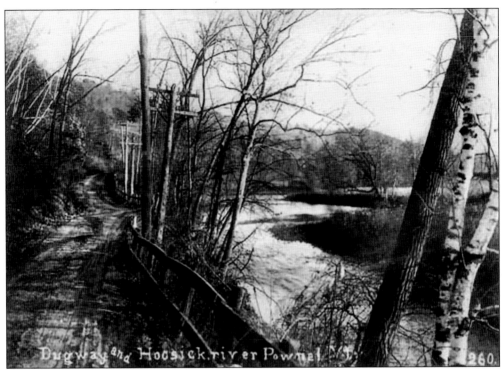

The Dugway, seen here about 1900, was one of Pownal's earliest roads, dug along the Hoosic River bank near the Massachusetts border. Local lore tells how a band of Mahicans could not be defeated "until the rocks wept." They were defeated by Mohawks when the spring, "weeping rocks," began to drip. This tale apparently first appears in a poem by Williams College student William Tatlock in 1845. (Courtesy of Helen Strobridge.)

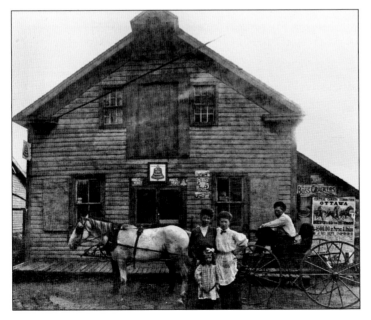

Originally a barn owned by Solomon Wright Jr. and dating back to Revolutionary War times, this may have been Pownal's oldest store. It was owned by John Potter in the 1800s and was sold to O. D. and Emma Card. Children called it the "gum store" in the 1900s. Notice the telephone signs. The first telephone switchboard, or "central," in town was located there. In 1943, the store was demolished. (Courtesy of Sylvia Proud.)

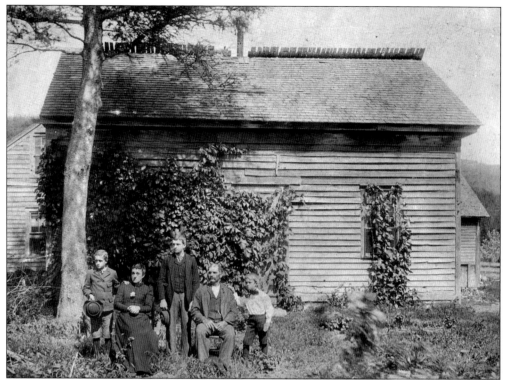

"The Nest" is the only identification on this photograph, which shows a family sitting in front of their home in Pownal. It once stood across from the current post office and firehouse in Pownal village but was torn down. This photograph serves to remind all who have family and community pictures to identify the people and places for those who will own them in the future. (Courtesy of Jeanne Quinn.)

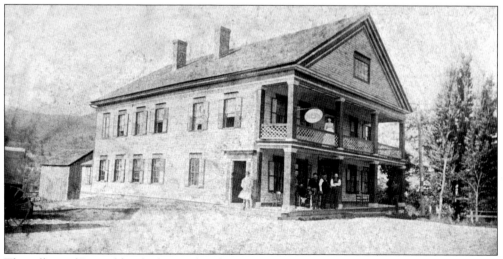

The village of Pownal has had many hotels over the years. The Pownal House, shown here, was also known as L. and G. Burrington's Exchange Hotel and later as the Wayside Inn. It was the largest hotel in Pownal and the most attractive to wayfarers. The building burned around 1900. (Courtesy of Joan Cannell.)

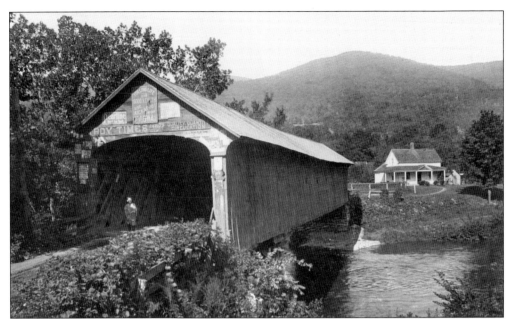

The covered bridge over the Hoosic River in Pownal was built as a lattice construction in 1830 by Noel Barber. In this picture, taken in 1909, signs advertise Perline, Octagon Soap, "Kickapoo for long life," and the *Troy Times*. The Potter House is visible across the river. Wright's woolen mill, created during the Civil War to provide cloth for soldiers' uniforms, stood next to the bridge. (Courtesy of Mary Louise Mason.)

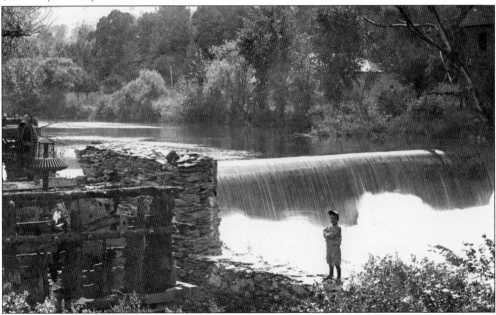

The dam in the village of Pownal powered several mills over the years. According to Joe Parks's book *Pownal, A Vermont Town's Two Hundred Years and More*, first on the site was Seelye's Mills, then a sawmill in the 1850s, and finally Wright's woolen mill in the 1860s. An early business missing from photographs was the nearby Lincoln Carriage Manufactory. (Courtesy of Mary Louise Mason.)

The brick powerhouse and smokestack are all that remain of Wright's mill after it was destroyed by fire in 1905. The mill produced woolen cloth for soldiers' uniforms during the Civil War and later yarn for hosiery, though it never competed on the scale of the larger mill in North Pownal. After the fire, the mill was never rebuilt. (Courtesy of Mary Louise Mason.)

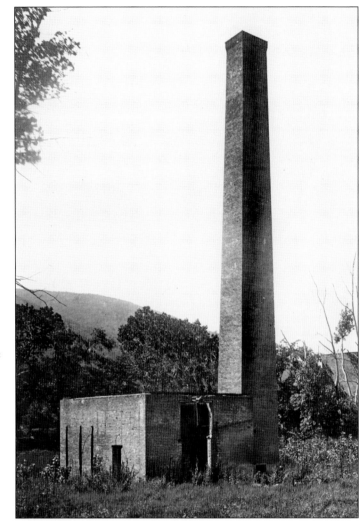

Fire was a real danger and a constant threat. The first fire station that people remember in Pownal was this small building used to house the hand-drawn pumper cart. It was located next to the Methodist church on Church Street. By 1994, it had fallen into disrepair and was dismantled. The village of Pownal is now served by the Pownal Fire Protective Association, Inc. (Courtesy of the *Bennington Banner.*)

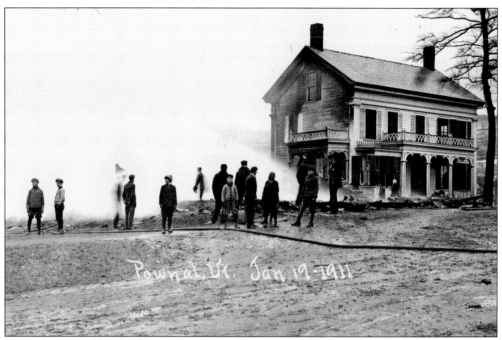

On January 19, 1911, the Pownal Baptist Church, its carriage barn, the A. G. Parker and Sons general store (which housed the town post office), and several small buildings all burned. A "patent fire extinguisher," ironically, was blamed for starting the conflagration. Firefighters could do little when they arrived except try to save the Parker residence next door, seen here. The church had been built in 1843. (Courtesy of Helen Strobridge.)

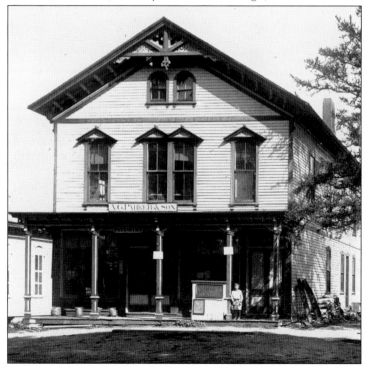

Arthur G. Parker and his sons, Gardner and Arthur, built a new store, shown here in 1911, shortly after their earlier store burned. The store carried everything from food and clothing to medicines and agricultural equipment. (Courtesy of Mary Louise Mason.)

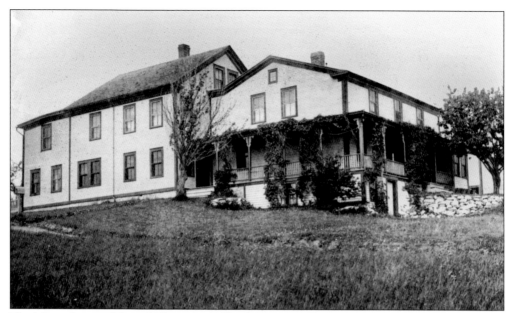

The Mason farm on Mason Hill was owned by the Anson Allen Mason family. The large farmhouse contained more than 20 rooms, which were rented out to boarders in the summer for $1 a day. Guests included teachers on vacation and summer people from New York who came to Pownal on the train. The farmhouse was taken down in the 1940s. (Courtesy of Mary Louise Mason.)

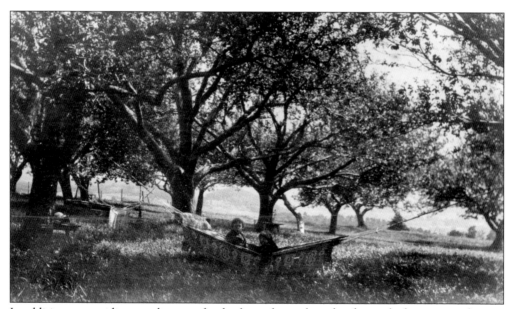

In addition to providing another crop for the farm, the apple orchard near the house was a favorite resting place for both boarders and farmhands. The farm workers often used the hammocks while they waited for dinner. (Courtesy of Mary Louise Mason.)

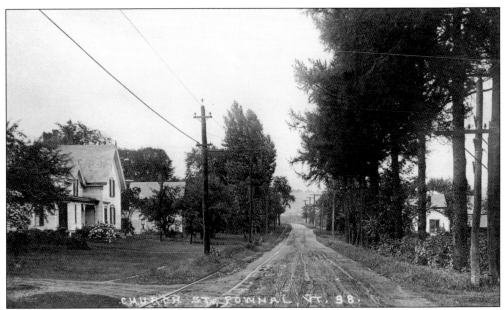

The trolley line in Pownal remained after the Berkshire Street Railway closed as a result of flood damage in November 1927. By the 1930s, town road conditions had improved. This view looking east on Church Street shows the trolley tracks, no longer in use. The earlier Methodist church sits just off the picture to the left. (Courtesy of Mary Louise Mason.)

On March 6, 1934, the ice on the Hoosic River had broken up, and the river overflowed its banks. The foundation of this home was washed away. The flood also damaged Pownal's last remaining covered bridge in Pownal village. The Hoosic flooded again in 1946, and the bridge was damaged again. It was torn down in 1949. (Courtesy of the Pownal Historical Society.)

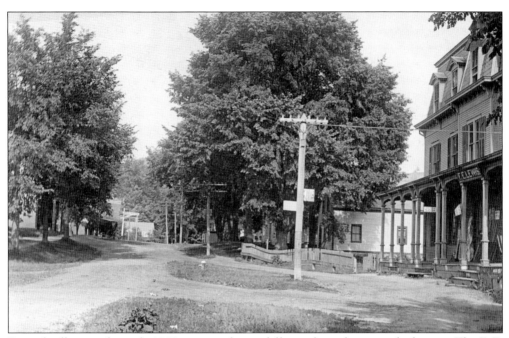

Pownal village in the early 1900s appeared very different from the way it looks now. The F. E. Lewis Store (right) fell into disrepair. Many other houses and businesses in this part of town have disappeared over the years. (Courtesy of Helen Strobridge.)

The old Lewis Store was burned by firemen in 1965 to make way for the new Solomon Wright Public Library, which opened in 1966. This aerial view encompasses the Methodist church, which burned in 1980, at the bottom of the picture; the Hoosic River running through the middle; and, hidden by the smoke, the DeVoet/Mooar-Wright house. (Courtesy of the Pownal Historical Society.)

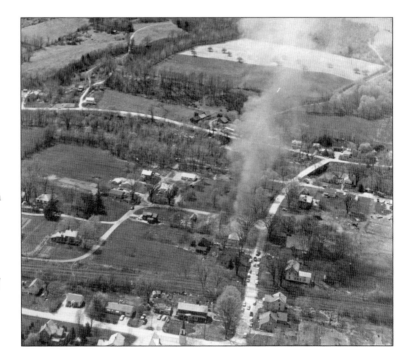

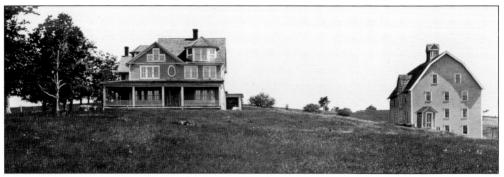

This mansion on Mason Hill near Williamstown, built by Dr. Lewis Niles of New York City in the early 20th century, was intended to be a sanatorium for tuberculosis patients, but the property was never used. The building was torn down in the 1920s, and the land was acquired by the Town of Williamstown as part of its watershed. (Courtesy of Mary Louise Mason.)

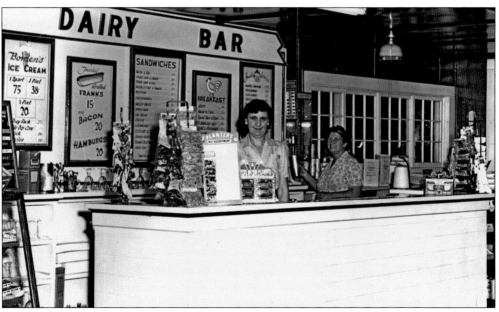

In 1946, Henry and Lillian Bassen and Harry and Gesine Siedenburg (Lillian's parents) bought Prouds' Modern Cabins and dairy bar from Winfred "Nick" and Emma Proud. The property was renamed Ladd Brook Cabins and then Ladd Brook Motel and Restaurant. Here Lillian (left) and Gesine stand behind the counter of the dairy bar. (Courtesy of Henry Bassen.)

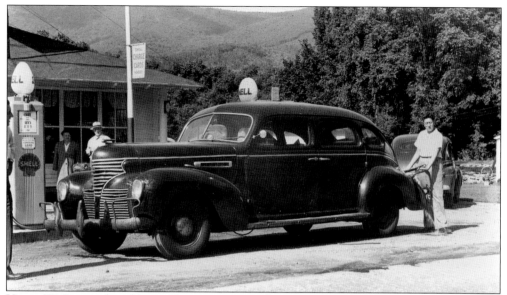

Henry W. Bassen found himself pumping gas at his parents' Ladd Brook Dairy Bar and Gas Station. Bassen had been a young boy growing up in Brooklyn, New York. Now he was pumping gas in addition to scooping ice cream, waiting on customers, and keeping up with the other chores necessary to the business. (Courtesy of Henry Bassen.)

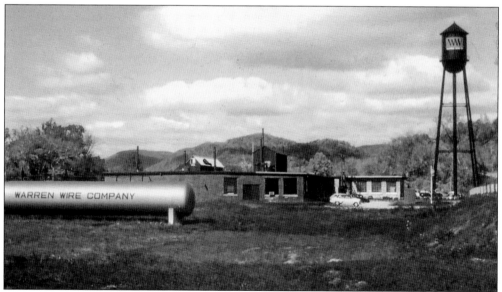

John Cook founded the Warren Wire Company in 1947 in Williamstown, Massachusetts. The company was named after Cook's oldest son, Warren. In 1948, a 200-by-60-foot building was constructed in Pownal and then expanded. In 1951, Cleveland Dodge created Teflon-coated wire here. Soon more space was needed: Plant 2 and Plant 3 were housed in Pownal Center. General Cable Corporation bought Warren Wire in 1963. (Courtesy of Andy Dodge.)

The sawmill at Valley View Farm on Northwest Hill was used by Harry Beals Sr. and Harry Jr. to build additions to their barns. Allen Beals Sr. stands on the woodpile, while Harriet Beals and her mother, Laura Pratt Beals (in the white dress), stand on the shavings pile along with two others. A large long belt turned the saw; power was supplied by a John Deere tractor's power takeoff. (Courtesy of Betsy Beals.)

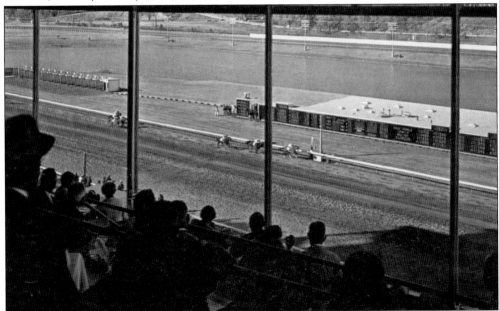

The Green Mountain Race Track brought Thoroughbred and harness racing to Vermont in 1963. By 1977, the horses had been replaced by greyhounds. Although the setting was beautiful and the track provided employment for many residents and others who moved into town, low attendance eventually forced its closure. The site, being developed for alternative energy businesses, currently plays host to occasional fairs, car shows, and bingo games. (Courtesy of Donna Ianni.)

Four

NORTH POWNAL

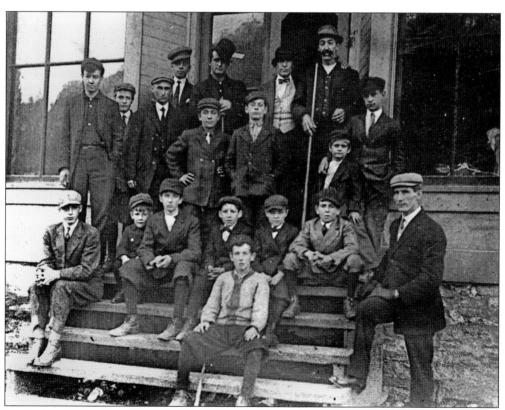

In the late 1920s, Sam Champney stands with his pool cue in front of his general store and barbershop in North Pownal. The store stood across the Hoosic River from the mill. Others in the photograph are identified as Beechard, Wells, Tatro, Willette, Remio, and Lozo. The store burned in the 1960s. When Champney emigrated from Canada, his first name was Hormisdas, but, like many immigrants, he adopted an Anglicized name. (Courtesy of Barbara Champney.)

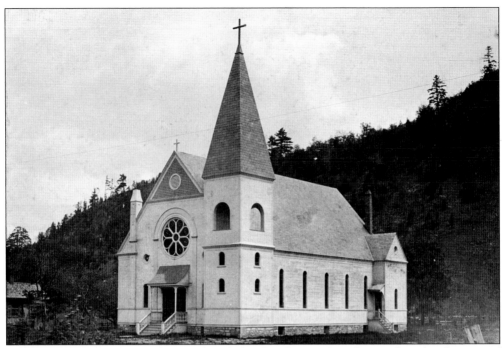

Our Lady of Lourdes, the North Pownal Catholic church, served as a house of worship for many of the immigrants who came from Canada to work in the cotton mill. In 1898, the church building was constructed with funds raised through raffles and bake sales. Prior to that, Fred Smith opened the second floor of his general store (later Ben Powell's store) for North Pownal Catholics to celebrate Mass. (Courtesy of Melba Cooper Estate.)

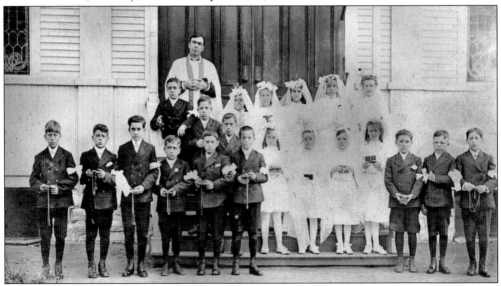

Young boys and girls pose for this First Communion photograph with their priest in front of the Catholic church, Our Lady of Lourdes, before World War I. In its early days, given the number of French Canadian members, services were conducted half in French and half in English. A priest came from Rutland for the service and stayed for the weekend. (Courtesy of Melba Cooper Estate.)

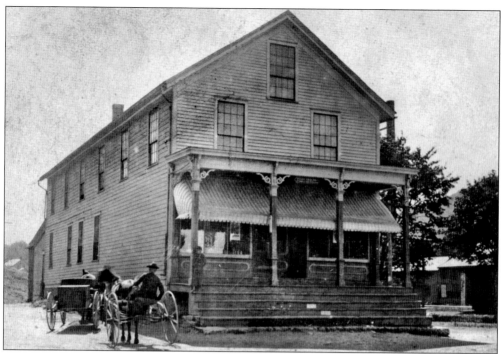

Smith's Store and Post Office in North Pownal was once the Lewis Store and later Ben Powell's store. The store served as a major source for food and other necessary personal items for the mill workers of North Pownal. The mill and the railroad were just west of this store, as was the covered bridge across the Hoosic River. (Courtesy of Barbara Champney.)

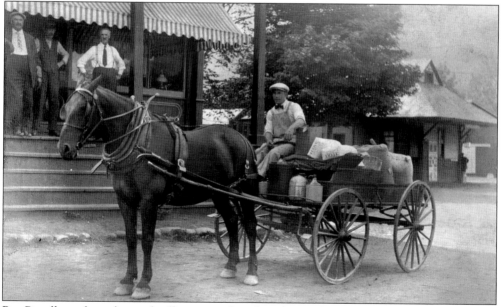

Ben Powell stands on the porch of his store in his white shirt and tie while Ernie Wilcox delivers the mail with his wagon. In the background is the North Pownal railroad station, where Wilcox picked up the mail. French Hill, where many workers lived, was just east of the store. The railroad station is gone, but the store remains, as do many workers' homes. (Courtesy of Melba Cooper Estate.)

The North Pownal bridge near the railroad tracks that ran between the Hoosic River and the cotton mill had been built in the early 1800s but washed away in the flood of 1938. Richard Champney watched it go down with a lighted lantern still hanging in it. Beyond the bridge to the left can be seen the general store owned by Champney's grandfather Sam. (Courtesy of Barbara Champney.)

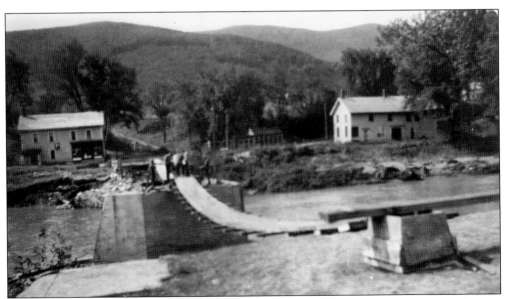

After the original bridge in North Pownal washed out in a 1938 storm, a temporary bridge was built in 1939 so that residents and workers in North Pownal could get from one side to the other. In the background on the left are Sam Champney's store and Ernie Wilcox's barn. (Courtesy of Melba Cooper Estate.)

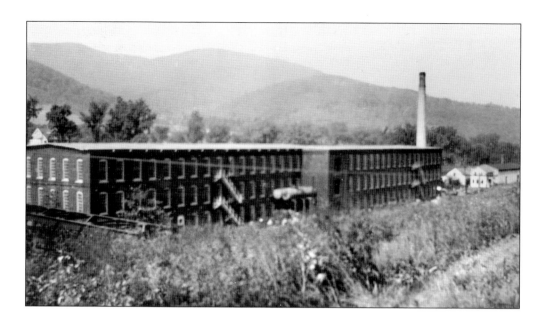

The original mill on this site was Richard Brown's gristmill. In 1813, it became Ethan Brown's cloth and wool mill, which burned in 1840. Brown rebuilt, and then R. Carpenter enlarged it into a woolen mill in 1850. That mill burned in 1855 and again in 1863. In 1866, the Plunckett and Barber Company rebuilt it as the cotton mill pictured here. This was the mill where Lewis Hine took his child labor photographs. Finally, in 1937, the building became a tannery. EPA sanctions led to its closing in 1988 and being demolished later. Designated a Superfund site because of contaminants from the mill's wastewater lagoons, the site is now a recreation area. Below, in the 1930s, Richard Champney and his uncle Alfred "Dutchy" Champney stand with the mill building in the background. (Above, courtesy of Barbara Champney; below, courtesy of Melba Cooper Estate.)

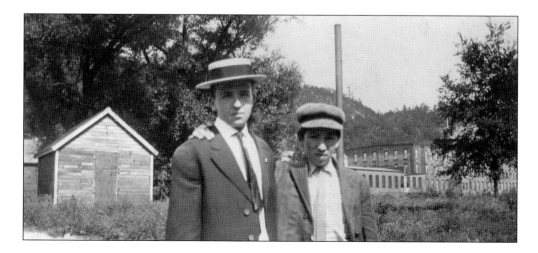

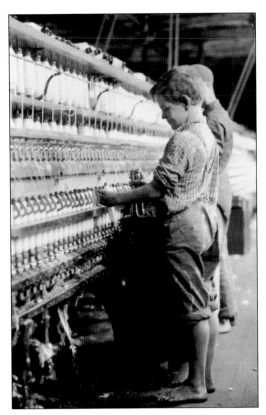

In 1910, Lewis Hine travelled the eastern United States documenting young children working in hard occupations for a Congressional committee investigating child labor practices. Of this picture, Hine wrote, "Clarence Wool, 11 years. Spinner in North Pownal Cotton Mill. Worked only during vacation." Another photograph identifies him as Clarence Noel. Not wanting mill owners to learn his purpose, Hine evidently scribbled notes quickly. (Courtesy of the Library of Congress.)

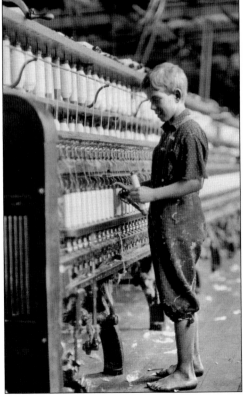

Lewis Hine photographed a "young doffer" working in the Plunkett and Barber Cotton Mill in August 1910. The doffer's job was to change the spools of thread as they ran out. This could be a dangerous task, with the risk of losing a finger if the boy slipped. Hine often camouflaged his real intent by pretending to be taking photographs of the manufacturing procedures. (Courtesy of the Library of Congress.)

Lewis Hine identified this girl as "Addie Card, 12 years. Spinner in North Pownal Cotton Mill. Vt. Girls in mill say she is ten years. She admitted to me she was twelve; that she started during school vacation and new [sic] would 'stay.' " Hine also called her an "anaemic little spinner." Card died in 1993, never knowing her photograph's impact on Congress and labor laws. (Courtesy of the Library of Congress.)

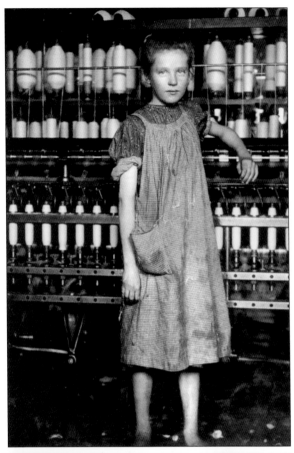

Lewis Hine's notes say, "Every one of these was working in the cotton mill at North Pownal, VT, and they were running a small force. Rosie Lapiare, 15 years; Jane Sylvester, 15 years; Runiel [?] Cird, 12 years; R. Silvester, 12 years; E. [H?] Willett, 13 years; Nat. Sylvester, 13 years; John King, 14 years; Z. Lapear, 13 years. Standing on step. Clarence Noel 11 years old, David Noel 14 years old." (Courtesy of the Library of Congress.)

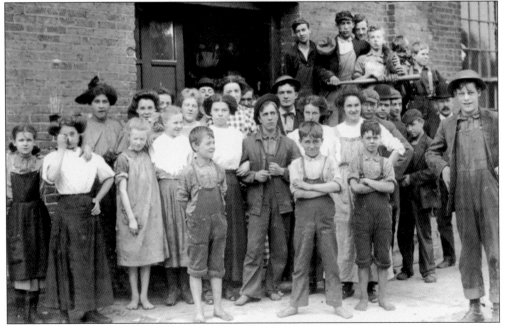

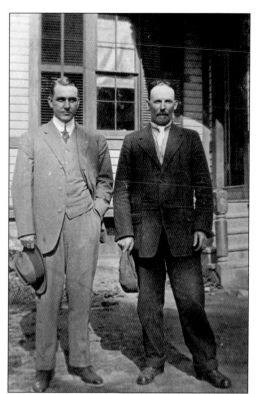

Descendants of mill owners often acquired leadership roles. Here, in 1913, Theodore R. Plunkett (left), employed as manager of the Greylock Mill, stands next to Clayton Thompson, the husband of Alice Blanche Peckham of Pownal. Plunkett was the grandson of William B. Plunkett, who, along with Daniel Barber of Pownal, founded the Plunkett and Barber Mill in North Pownal. (Courtesy of the Solomon Wright Public Library.)

On July 19, 1909, Ambrose "Amby" Moses McConnell (1883–1942) hit into Major League Baseball's first triple play. McConnell (far left) stands by, from left to right, Cleveland Naps shortstop Neal Ball (the playmaker), Heinie Wagner, and Jack Stahl. Teenager McConnell worked 50 hours for $6 weekly in the North Pownal cotton mill before the Boston Red Sox recruited him. (Courtesy of National Baseball Hall of Fame Library, Cooperstown, New York.)

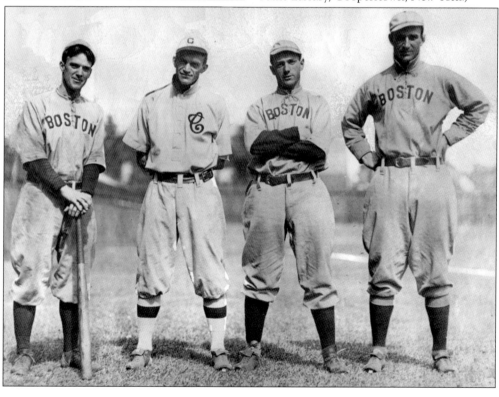

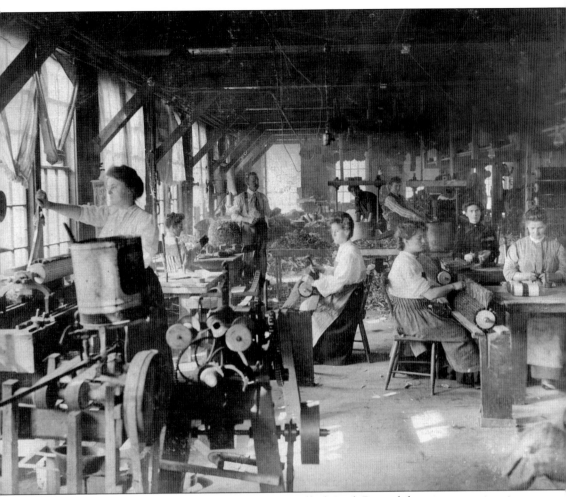

This unique view of adult workers inside the cotton mill of North Pownal shows women trimming the rolls of finished cloth, brushing them to clean them of lint, and rolling them on large spools. Behind them, men work with large tubs, while what apparently are piles of discarded trimmings cover the floor. An electric light bulb hangs from the ceiling. (Courtesy of Barbara Champney.)

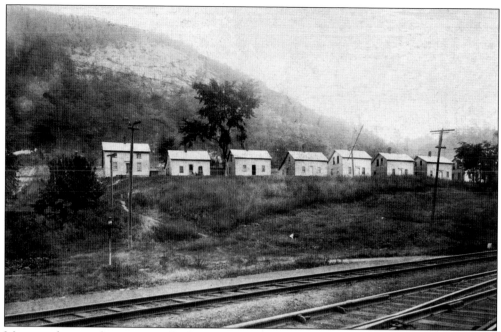

Many workers in the cotton mill of North Pownal lived in these houses lining "French Hill," so called for the number of French Canadians who immigrated here for employment. This view from around 1913 was taken from the side of cotton mill by the railroad tracks. (Courtesy of the Solomon Wright Public Library.)

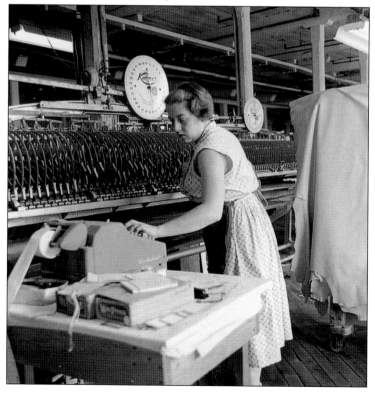

The tannery succeeded the cotton mill. Marion Burdick reads the scale above her head and enters the hide measurements before they are shipped out. Workers treated each other as family. Men in the basement carried out the sweaty work of trimming and scraping hides, while women and men on the floors above performed tasks ranging from stretching, to coloring, to softening, to printing special designs. (Courtesy of the *Bennington Banner*.)

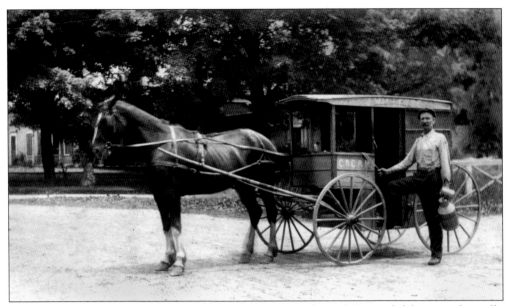

Joe Willette and his horse Topsy made daily trips around North Pownal delivering the milk. Many people who remember the milk from those days talk about how good milk tasted before pasteurization was required. Farmers and others hoping to earn a better living became entrepreneurs to make ends meet. (Courtesy of the Solomon Wright Public Library.)

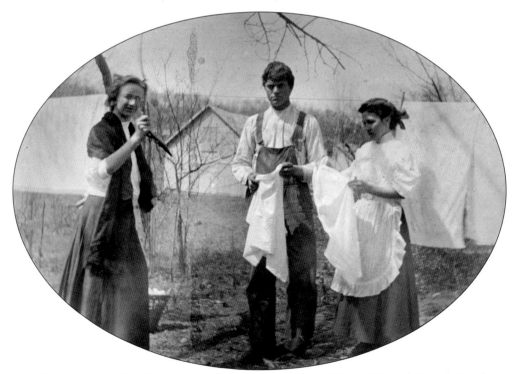

On Mount Anthony Road just up from North Pownal, young Harry Wilson helps relatives hang out their clothes to dry. Their farm and its accompanying cluster of outbuildings was a beautiful place to live and do the daily chores. (Courtesy of Ray Rodrigues.)

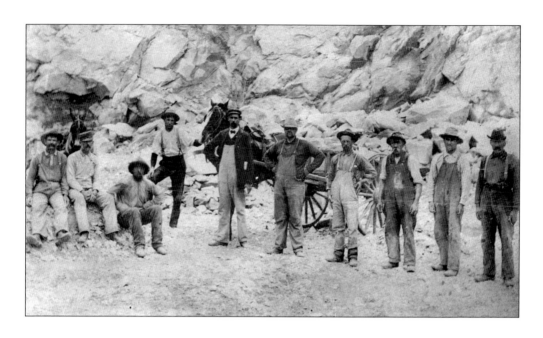

The employees and their horse teams at the limestone quarry of North Pownal, shown above in 1901, worked hard hours. Below, in 1914, five teams are visible. After the limestone was crushed, the teams hauled it either to waiting rail carts or directly to the kilns, where it was heated for many hours to break it down. The resulting lime was then bagged and shipped via the railroad running beside the mill to be used for purposes ranging from iron ore processing to farming. Over the years, a variety of owners operated lime quarrying and kiln operations in North Pownal—owners like Whipple, Burden, and Rorabach. A. Whipple and then Henry Burden and Sons operated on the northern edge of the quarried hill. (Both, courtesy of the Pownal Historical Society.)

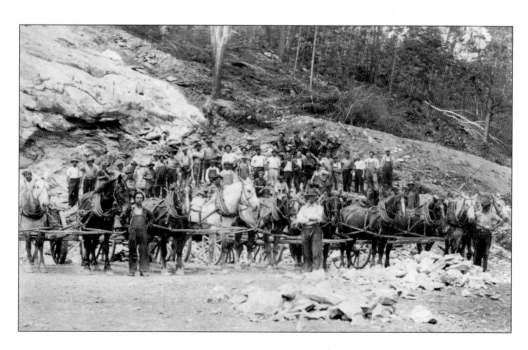

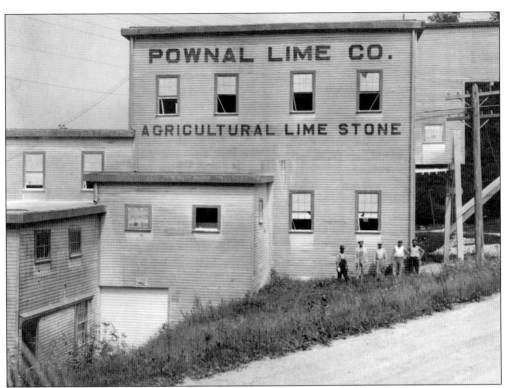

The Pownal Lime Company building, seen around 1914, stood between the southernmost quarry and the railroad tracks. From left to right, W. M. Knapp (fireman), William Callahan (crusher), David Wilson (tipple), Martin Welch (miller), and Gordon Niles (engineer) stand along the wall. D. J. Lawless was the superintendent. (Courtesy of the Pownal Historical Society.)

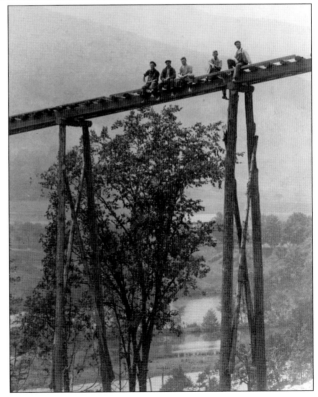

This trestle carried the lime cars from the quarry to the crushing factory below. When it was damaged in 1936, these workers came to repair it, but the Pownal Lime Company closed down shortly afterward. (Courtesy of the Pownal Historical Society.)

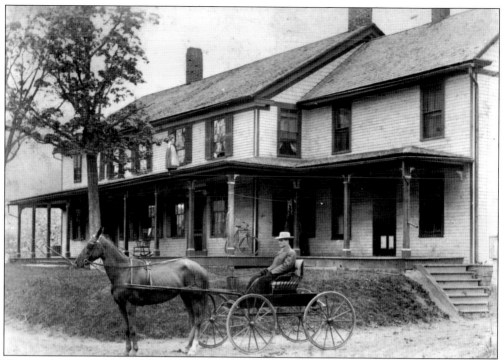

The gentleman posing with his horse and wagon in front of the home once owned by the Rudds and, before them, the Tatros, is oblivious to the woman washing windows on the roof behind him. She has propped open a window with her pitcher so that she does not get locked out. At the time of this photograph, the middle class in North Pownal was quite proud of its accomplishments and eager to have evidence of that captured by a photographer. The growth of the mills in the town, the arrival of the railroads, and the various support services that grew up around them enabled North Pownal to become the most prosperous of the Pownal communities in the latter half of the 19th century and the early 20th century. (Both, courtesy of Melba Cooper Estate.)

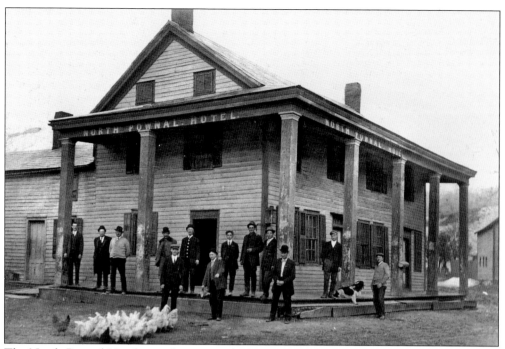

The North Pownal Hotel, seen here around 1900, was used partly as a school and partly for a cider mill. To the right is the barn that later became the Whipple Tea Barn. Located near Dark Woods Road and the lime kilns, this hotel burned down in 1928. Chickens congregate to be fed in what appears to be the late winter. (Courtesy of Barbara Champney.)

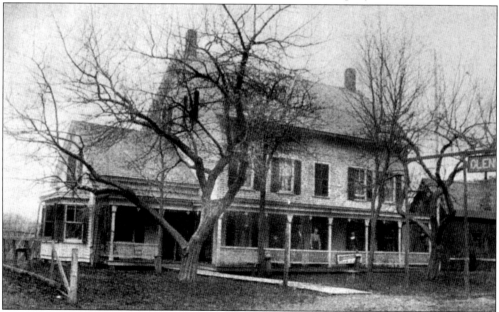

The Glenwood Inn was part of the Whipple estate in North Pownal and dated back to at least 1832. To the right stands the livery where the inn rented horses and wagons. During Prohibition, "bathtub gin" was made at the inn. Local history claims that the inn served as a safe place for slaves to hide on their way north. (Courtesy of Judy Greenawalt and Barbara Champney.)

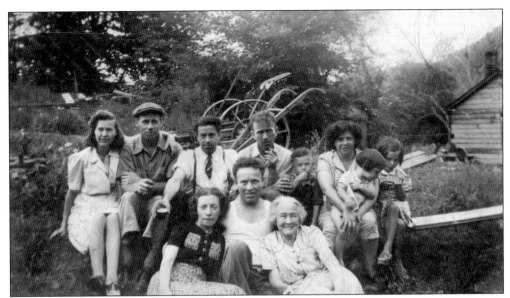

The Harris family gathers in the 1930s near the homestead of Flora Sarah Harris on the west side of the Hoosic River, across from the site of the North Pownal mill. From left to right are (first row) Betty Harris, Albert Henry "Joe" Harris, and Flora Sarah Harris; (second row) Nellie Proud, Wilfred Proud, Lewis Harris, Edward Harris, and Edward's wife, Georgianna (called "Pinkie"), with their children. (Courtesy of Sylvia Proud.)

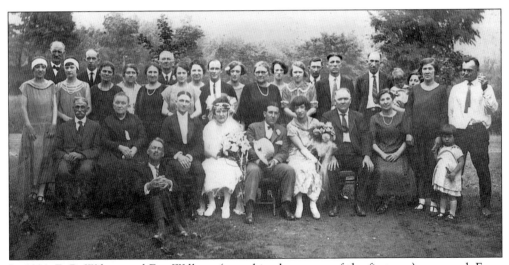

In 1924, E. B. Wilcox and Eva Willette (seated in the center of the first row) were wed. From left to right are (first row) Elmer Wilcox, Adella Wilcox, Albert Bellows (on ground), Ernest Wilcox, Eva Wilcox, Leeward Jaques, Celia Harris, Paul Willette, Celia Willette, Grace Gouger, Rita Jane Willette, and Arthur Gouger; (second row) Viola Belleau DeLisle, Geneva Hurley, Josephine Champney, Annie Belleau, unidentified, Oswald Hurley, Helen Champney, Frankie Wilcox, Victor Willette, Joe Champney, and Eva Willette with baby; (third row) Joe Willette, unidentified, Melvina Willette, Albert Belleau, Clara Hurley, Mary Edna Hurley, Harriet Tutor, and unidentified. (Courtesy of Jim Therrien.)

Five

No Whispering!
Sit Up Straight!

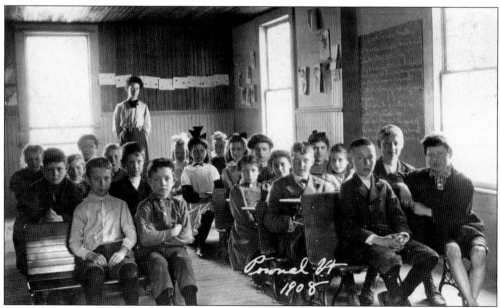

Answer the questions on the blackboard of this sixth grade at Oak Hill School in 1908: "Who was William Henry Harrison? Tell the story of the log. Why did we fight the British in 1812? How long did William Henry Harrison live after he became president? Tell the story of Andrew Jackson's boyhood. What were the four steps in Andrew Jackson's life? Tell how they sent the news of the completion of the Erie Canal." (Courtesy of Mary Louise Mason.)

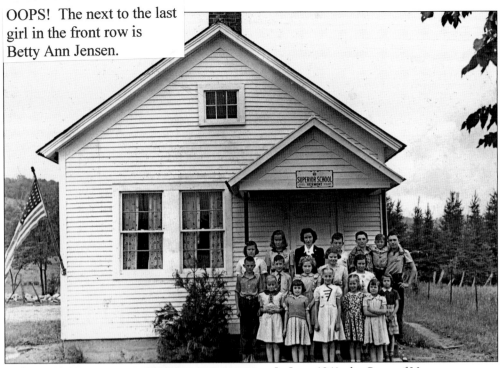

OOPS! The next to the last girl in the front row is Betty Ann Jensen.

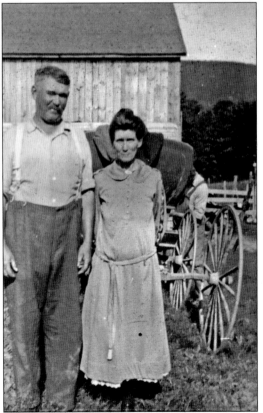

In June 1941, the State of Vermont designated the Barber School a "superior school." On June 9, 1962, the Barber School closed forever when schools were consolidated. Above, from left to right, are (first row) Edna Knights, Helen Martel, Betty Dewey, Joan Dewey, Beatrice Jensen, and Jane Vien; (second row) George Vien, Robert Benn, Martha Amadon, Charlotte Crosier, and Betty Blanchard; (third row) Beatrice Jensen, Frances Knights, teacher Madeline Tiernan, Jim Brown, Earl Lillie, William Vien, and Ardent Jensen. At left, Egbert and Lottie Amadon stand near their barn in East Pownal. Living next door to the Barber School, they boarded the "school marms" teaching there, and Lottie kept the fire burning in the big black furnace-type stove in the schoolhouse. The children at the school, as well as folks in the neighborhood, called the Amadons "Uncle Egbert" and "Aunt Lottie." (Above, courtesy of Charlotte Comar; left, courtesy of Harold McLenithan.)

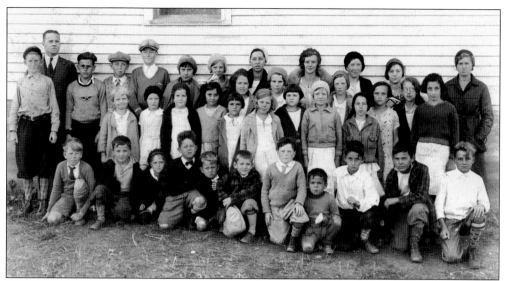

The picture above was taken on a day when the superintendent of schools, Francis Irons, paid a visit to Pownal Center School. Students are, from left to right, (first row) Victor Nielsen, Paul Niles, Dickie Lauzon, John Forcier, unidentified, Abe Morgan, Walter Patterson, Dick Niles, Arnold Langlois, David Niles, and Irving Holland; (second row) Julia Robb, Dorothy Welch, Barbara Morgan, Doris "Lolly" Langlois, Theresa Lauzon, Harriet Patterson, Elsie Nielsen, Florence Patterson, Charlotte Lauzon, Marsha Robb, Barbara Welch, Charlotte Dorman, Beatrice Lauzon, Mildred Lampman, and Cecile Langlois; (third row) "Buster" Welch, Supt. Francis Irons, Raymond Lauzon, Earl Chaffee, John Patterson, Inez Hayes, Alice Nielsen, Lee Welch, Marion Campbell, Rachel Morgan, Eleanor Wilcox, and the teacher, a Ms. Marshall. Below, schoolchildren at the Pownal Center School play baseball outside. Today the building is one of three senior centers in town, and the growth of trees and bushes has totally blocked any view of the homes on Center Street. (Both, courtesy of Frances Lampman.)

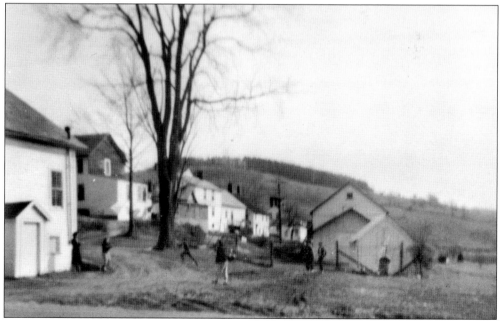

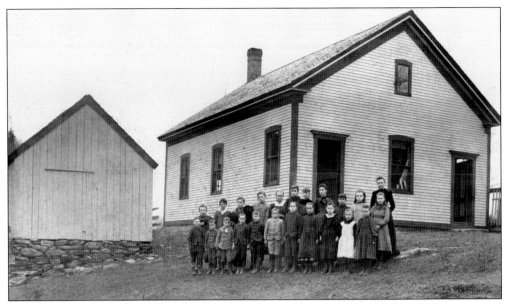

Pownal Center School children stand on the slope in front of the school with their teacher. Pictures of boys show them bare-footed in seasons other than winter. In 1880, Pownal had 11 school districts, with 11 women teachers and 6 male teachers. Approximately 460 students attended all schools then. (Courtesy of Ray Rodrigues.)

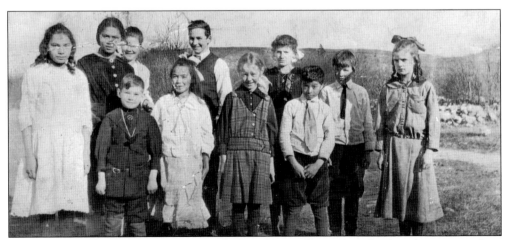

Around 1917, the students of Niles School, one of Pownal's smaller schools, take time out from a game of hide and seek, or perhaps it was Red, Red Rover, to pose for the camera. Niles School is now a private home. (Courtesy of Donna Ianni.)

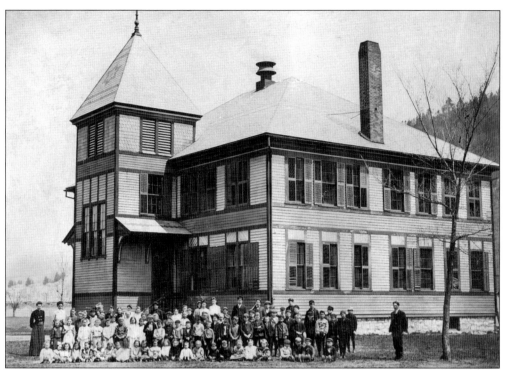

The North Pownal Graded School was built some time after the Civil War. North Pownal residents were dismayed when the decision was made to demolish the school because no new uses could be found for it. By 1965, children were bused to the new elementary school built in Pownal Center, leaving the site a Little League field. (Courtesy of Helen Strobridge.)

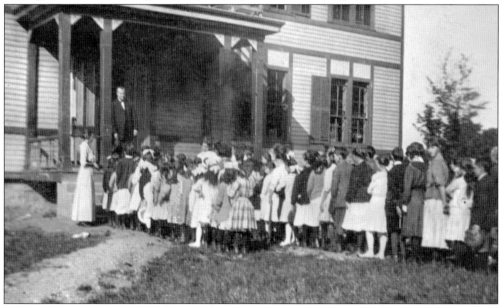

Around 1913, while the teacher stands waiting patiently on the school steps, the children line up in an orderly fashion after recess to return to their classes in the North Pownal Graded School. (Courtesy of Solomon Wright Public Library.)

Teacher Mary Purcell jokes around with Clarence W. Dickey, principal of the North Pownal Graded School (background left) around 1913. (Courtesy of Solomon Wright Library.)

Below, in 1915, the children standing at Maple Grove School are, from left to right, (first row) Walter Davis, Edward Flynn, Eva Crosier, Mildred Crosier, Eddie Williams, Harold Morgan, and Etta Davis; (second row) Alfred Williams, Walter Crosier, Florence Crosier, Grace Amadon, Bernice Morgan, Michael Sheehan, Martha Williams, and Clarence Williams; (third row) Andrew Crosier, Clarence Crosier, teacher Helen White, Mable Crosier, and Victoria Johnson. (Courtesy of Charlotte Comar.)

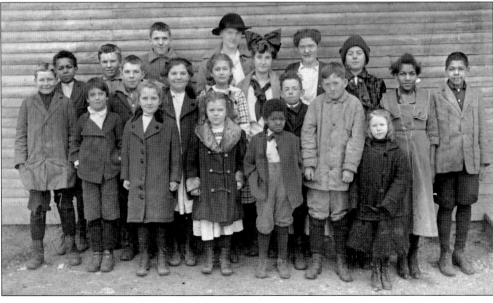

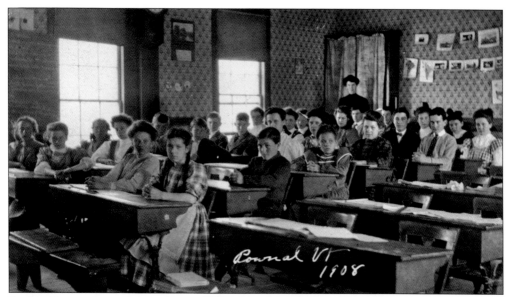

Sophie Norwood was the teacher in 1908 when these sixth-grade students at Oak Hill School listened attentively to their daily history lesson. Sophie was the mother of Helen Renner, who became the first librarian of the Solomon Wright Public Library and who wrote articles about Pownal and its history for the *North Adams Transcript*. (Courtesy of Mary Louise Mason.)

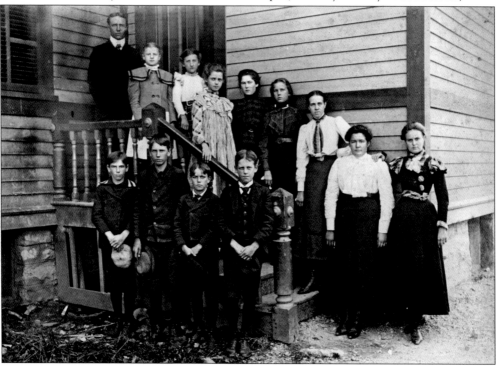

Teachers and students stand on the stairs of the North Pownal Graded School. The large school may have been necessary, in part, to educate the children of the French Canadians who worked in the woolen and cotton mills in town. Later child labor laws reinforced the need to educate those young children. (Courtesy of Melba Cooper Estate.)

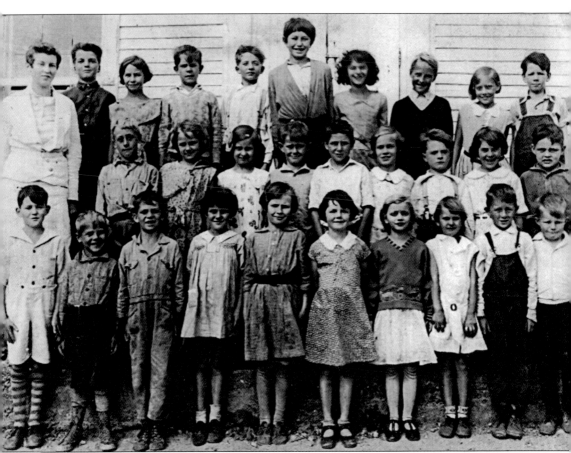

In October 1932, the students posed for this picture. From left to right are (first row) Harry Beals, David Brookman, Earl Pierce, June Sprague, Edith Pratt, Ann Pratt, Eleanor Ames, Eleanor Oldham, George Pratt, and Lyman Pratt; (second row) Lawrence Odell, Geraldine Smith, Junior Goodrich, Sterling Sprague, unidentified, Cynthia Proud, Norman Barber, Ellen Brookman, and Francis Haley; (third row) teacher Teresa Judge, Lawrence Pierce, Beulah Bump, Fred Baker Jr., Ross Barber, Robert Benjamin, Viola Benjamin, Ed Brookman, Hazel Beals, and Wilson Pratt. Today the Museum of Black World War II History can be found in the Oak Hill School. (Courtesy of George Pratt.)

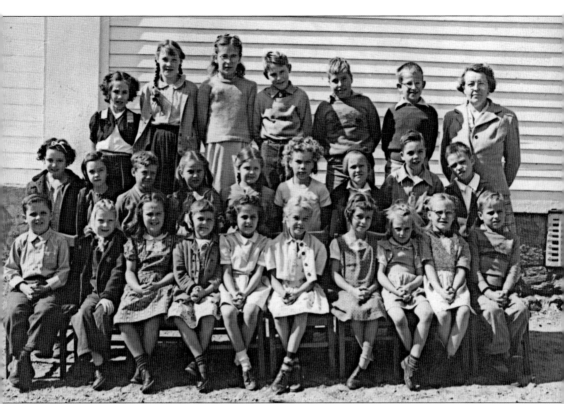

Noel Barber built Oak Hill Seminary, presumably in 1853. In 1947, the students posing for the photographer are, from left to right, (first row) unidentified, Barbara Rhodes, Helen Macomber, Etta Rhodes, Elaine Senecal, Laurel Hill, Jane Rust, Jean Pratt, Joan Pratt, and Robert Burdick; (second row) Marjorie Pratt, June Daniels, unidentified, Claudia Tornabene, unidentified, Carol Kimball, Mary Louise Palmer, Millard Daniels, and Fred Powers; (third row) Janet Pratt, Allison Hewitt, Doris Pratt, Albert Barham, Jimmy Rhodes, David Rust, and teacher Lulu Pratt. (Courtesy of Mary Louise Mason.)

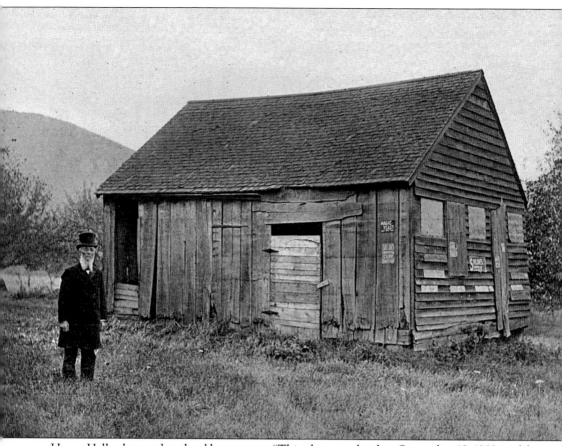

Henry Hall, who taught school here, wrote: "This photograph taken September 19, 1903 is of the old School house in which I kept school in the winter of 1841–42 in Pownal. Orrin Bates was the committee and I was engaged for three months. . . . I boarded around and received twenty dollars a month. . . . The teacher had been carried out and covered in the snow the year before. . . . The work was hard as the scholars numbered 65, from the child in a,b,c's to men and women grown, studying Latin and completing Adams Arithmetic and Day's Algebra. Attest Henry D. Hall." Then he added, "P.S. There were no churches in the village and the schoolhouse was used in which to hold meetings. President Mark Hopkins occasionally came from Williamstown to preach, and his brother Prof. Hopkins often did." (Courtesy of Bennington Museum.)

Six

ROCKS, MUD, CROPS, AND CRITTERS

The pastoral settings of Pownal may have appealed to photographers and artists, and indeed still do, but for the hill farmers, work was hard. The rocky land and poor soil provided little for farmers to work with, aside from raising sheep, pigs, and cows. Soldiers returning from the Civil War had seen what good farmland could be, and soon there was mass exodus from Pownal to lands in the west and south, first Ohio, then Indiana, then Michigan, and on to California. (Courtesy of Sylvia Hill.)

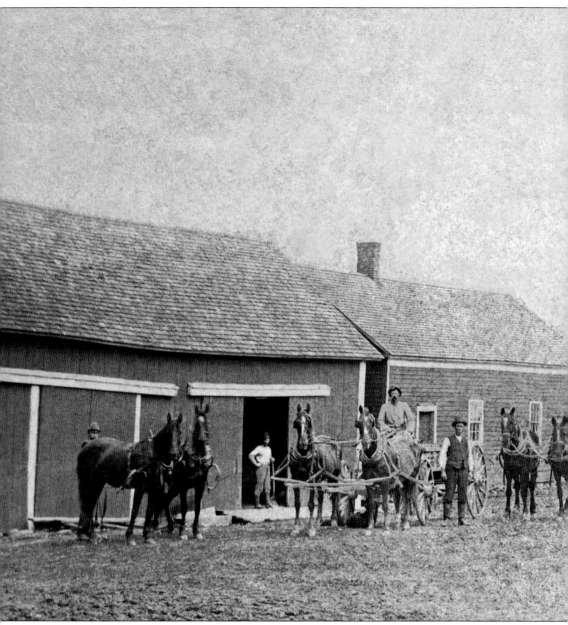

This scene captures how an entire family was necessary to run a farm during the late 19th century in Pownal. Four teams of horses demonstrate how their labor was essential to the farm's operations. Multiple barns and other outbuildings served varying purposes, such as icehouses, smokehouses,

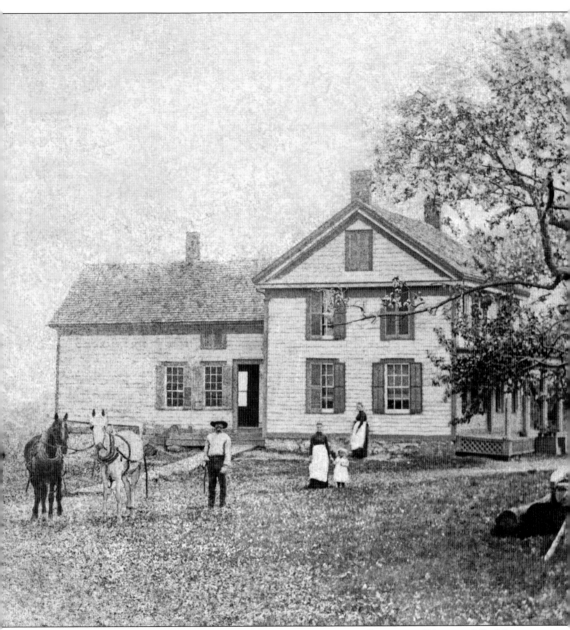

pig barns, sheep barns, corncribs, horse stables, granaries, root cellars, or well houses. Wealthier farmers may even have had a carriage barn for various wagons and buggies. (Courtesy of the Pownal Historical Society.)

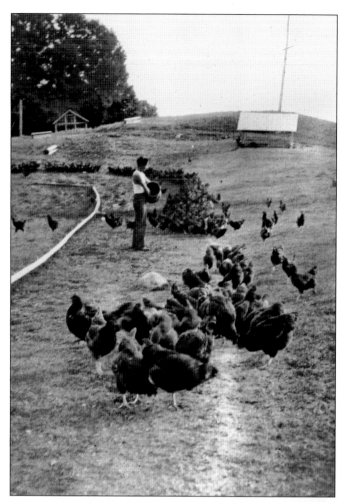

Poultry farms grew in Pownal during the 1920s and continued operating into the 1970s. George Goodwin and later William Blanchard were two of the larger operators, but every little farm raised chickens and eggs for food. Here one can see the mass feeding of chickens on Valley View Poultry Farm. (Courtesy of Donna Ianni.)

Valley View Poultry Farm, shown below in the 1930s, raised chicks for sale to other poultry farmers and, at one point, was selling as many as 55,000 chicks a year. Bill Blanchard and Norman Strobridge were two of the men who ran the operation. (Courtesy of Donna Ianni.)

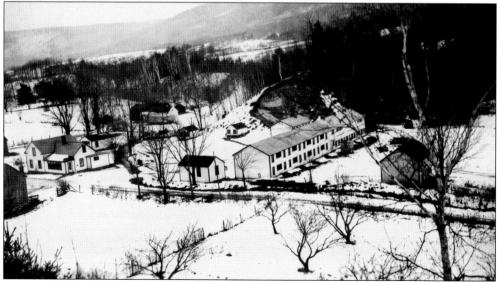

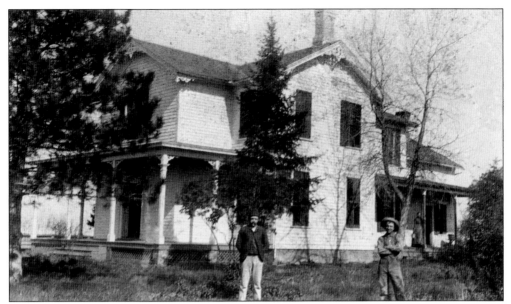

Following World War II, the Warren Mason family on Cedar Hill Farm owned the first milking parlor in Pownal. The machine milked six cows at a time, and it took seven hours to milk the 80 cows they owned then. Mighty Food Farm, a community-supported agricultural group, now operates the farm. (Courtesy of Mary Louise Mason.)

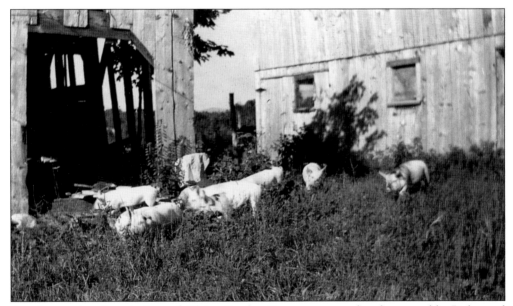

Another poultry farm in Pownal, Flying Feather Farm, was owned and operated by Perley and Grace Hibbard of Maple Grove Road. Although chickens were their main interest, cows and pigs could also be found on the farm. Here a litter of piglets romps in the tall grass by the barn. (Courtesy of Sam Hibbard.)

As a young girl in October 1911, Gladys Montgomery throws grain down for her flock of geese, ducks, and one chicken on the family farm on Montgomery Hill, which was located across the river from where she lived after marrying Charles Mason. (Courtesy of Mary Louise Mason.)

This picture shows young Harry Beals Jr. in his high-cut boots working with his family's sheep on Northwest Hill. Since sheep could graze on steep land, in the 1840s, Pownal had about six sheep for every human, many Merino sheep. After the Civil War, sheep raising gradually fell off. Throughout the woods of Pownal one can still see stone walls from where sheep were kept. (Courtesy of Betsy Beals.)

Andrew Crosier stops his sap collecting to pose with, from left to right, Evelyn Burdick, Marge Stockwell, and an unidentified woman sitting on top of his sap-gathering tank. Horses pulled the sled the tank sits on. Andrew's wife, Mildred, modified the jumper worn by Crosier so that his back could stay warm while his belly was inches away from the heat of the sap evaporator. (Courtesy of Charlotte Comar.)

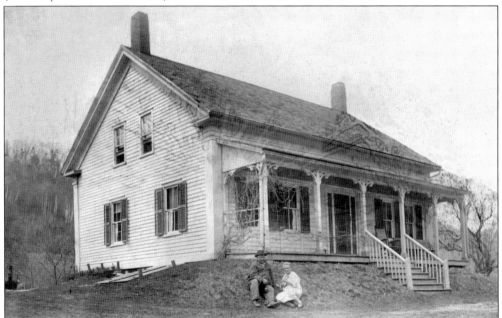

The Armstrong house, on the road from Pownal to Bennington, is seen as it looked in 1912 as the result of concerted family efforts. Armstrong family history tells of their having walked from the New York–Vermont state line to Pownal, taking all they owned with them. The family eventually grew and sold produce ranging from corn to pumpkins and maple syrup. (Courtesy of Keith Armstrong.)

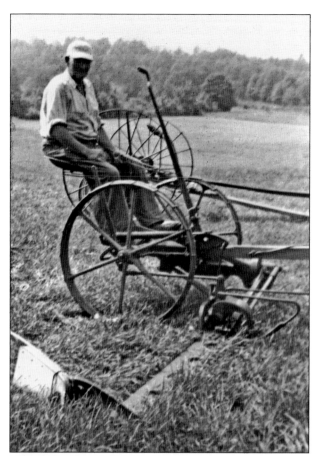

Egbert Amadon, hoping for a stretch of good weather, gets ready to lay down a field of hay with his two-horse mowing machine. Behind him is a one-horse rake waiting to be used as soon as the cut hay is dry enough to put in the barn. (Courtesy of Harold McLenithan.)

Below, neighbors gather on a Sunday afternoon in 1910 at the Christopher Amadon farm in East Pownal. This house burned in 1927. The woman on the left, holding the horse, is Abby Amadon, Christopher's wife. White horses, Daisy and Fanny, wait patiently while the dark horses welcome the new colt in the neighborhood. (Courtesy of Charlotte Comar.)

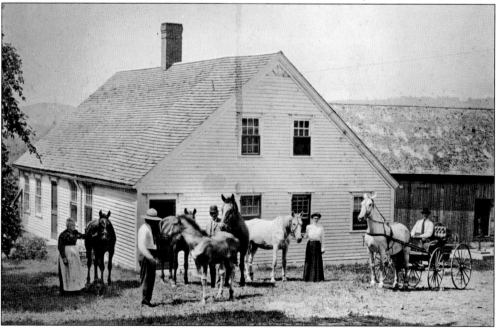

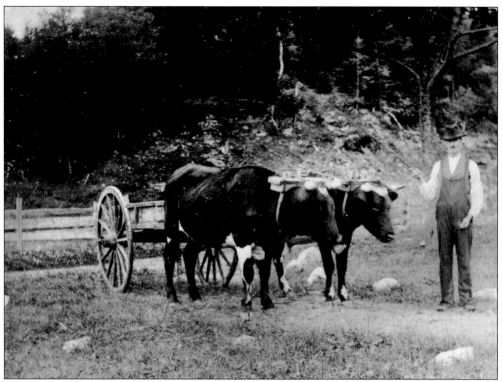

Loren Fowler poses with his father's oxen, Pat and Mike. Oxen were often used in place of horses for the heavier tasks on a farm, including hauling logs, clearing a field of large rocks, and blazing a trail through heavy snow. (Courtesy of Rachel Mason.)

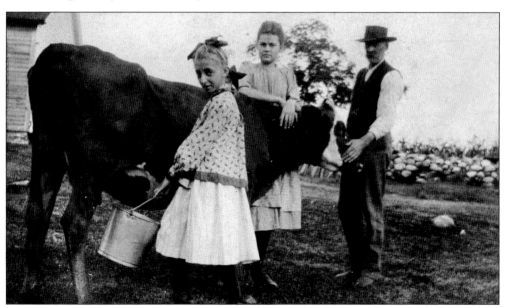

In this early-1900s picture, Bossy stands quietly while country folks Eros Hicks and daughter Mildred wait for city cousin Maybelle Darlin to try her hand at milking a cow during her visit to the Hicks farm on Maple Grove Road. (Courtesy of Charlotte Comar.)

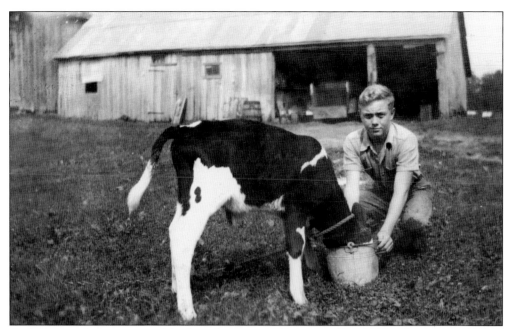

Aside from gathering eggs and feeding the pigs, another one of Sam Hibbard's chores on Flying Feather Farm was feeding this young calf. Sam and his wife, Marietta, still enjoy living on the family farm on Maple Grove Road. (Courtesy of Sam Hibbard.)

Ernest Murray and Addie Burrington Murray delivered wood in East Pownal on New Year's Day to make money, "or else it was a bad sign." Ernest was in the cavalry during World War I, and back home, he trained his horses so that one of them could actually climb stairs. (Courtesy of Gertrude McIver.)

Kenneth Purdy wanders through his grandfather's cornfield in 1922. Some winters later, when asked to bring in wood from the woodshed, Kenneth protested because it was "chilly." From that day forward his nickname was "Chilly." Kenneth lost his life in the South Pacific during World War II. (Courtesy of Charlotte Comar.)

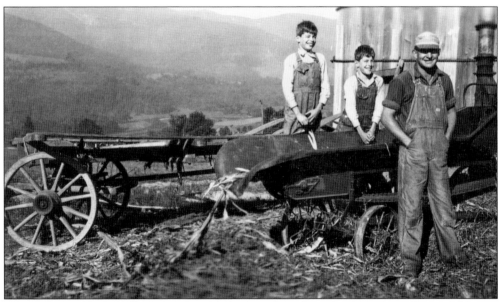

After having cut cornstalks by hand and unloading them from the wagon into the corn chopper, (from left to right) Joel, Bruce, and Walter Morgan Burrington Jr. take a break. The next step was for the chopper to chop the corn and blow it into the Burringtons' silo, where it was stored for food for their livestock throughout the winter. (Courtesy of Karen Burrington.)

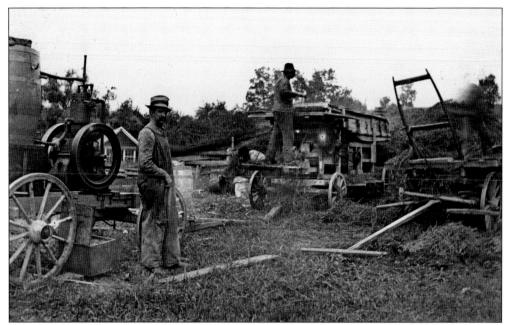

In late summer, this threshing machine traveled through parts of Pownal when farmers "changed works" by helping their neighbors cut oats and run the thresher, separating the grain from the straw. The grain was stored in granaries for feed, and the straw was used for bedding for the farm animals. Each day, farmers' wives would set out dinners fit for a king for these hardworking men. (Courtesy of Frances Lampman.)

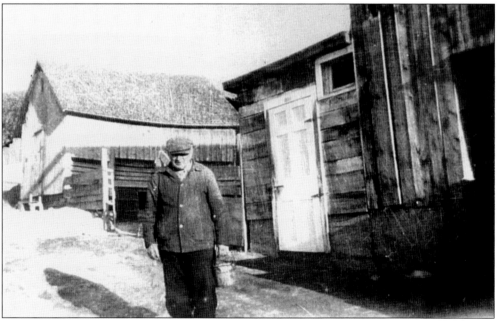

Henry Amadon, having finished milking his cows, stops in front of his barn in East Pownal with a small can of milk in hand to ponder what farm chore to undertake next. Amadon served as Pownal's representative to the Vermont Legislature as well as a member of the Pownal Town Committee in the early 1950s. (Courtesy of Harold McLenithan.)

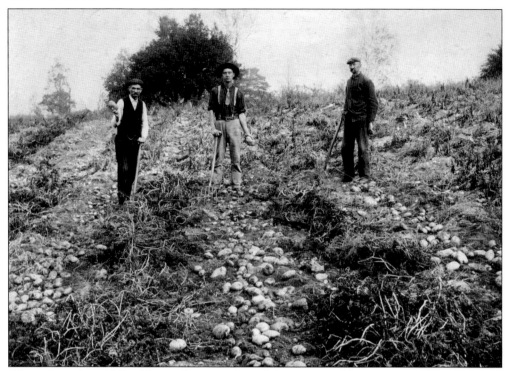

Along about the middle of September it was "tater" digging time. These men stand by a bountiful crop of potatoes on the Wilcox farm. After letting the potatoes dry a bit, the dirt was brushed off, and they were stored for the winter in big wooden barrels in the darkest, driest part of the cellar. (Courtesy of Solomon Wright Public Library.)

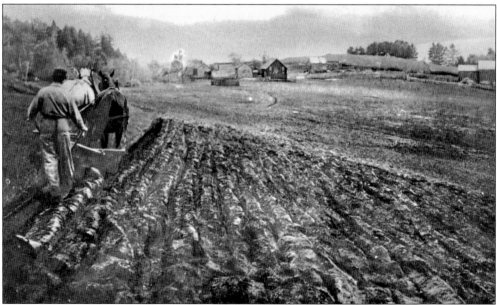

Loren Fowler plows his north field on Carpenter Hill. Hill farmers made the best of what they had, constantly moving the rocks that seemed to work their way up through the soil every spring. The Fowler farm survived year after year. (Courtesy of Rachel Mason.)

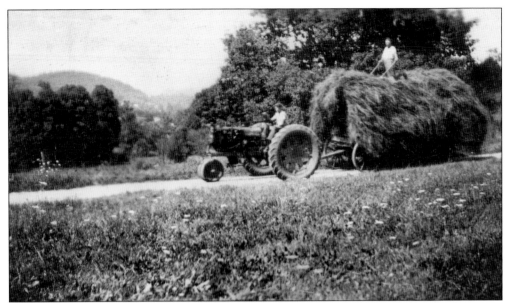

Warren Mason Jr. drives the tractor with his father, Warren, on top, bringing in a load of hay in the 1940s. Warren Sr. and his family worked their old farm on Cedar Hill Road. In 1935, Mason Sr. bought Cedar Hill Farm from A. B. Gardner Jr., and he farmed it until his death in 1967. (Courtesy of Anson and Jackie Mason.)

In 1983, a young admirer waits patiently with Ray Armstrong for the sap in the evaporator to turn to golden maple syrup. Quick boiling after gathering and keeping the equipment clean are big factors in making high-quality syrup. Frequently, the sugar maker boiled all through the night. (Courtesy of Keith Armstrong.)

Seven

ENJOYING THE GOOD LIFE

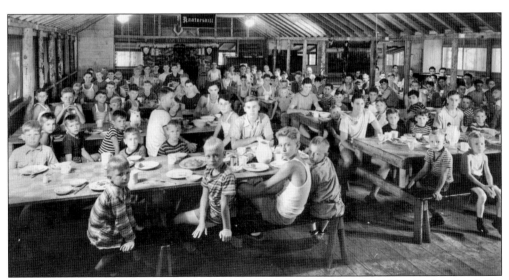

Herbert Lorenz founded Kamp Kaaterskill, a private camp for boys, in 1921 at Barber Pond. For $7 a week, boys aged 11 to 18 spent July learning to "direct energy, develop ability, cultivate right habits and build Christian character," as the Kamp brochure proclaimed. The boys were housed in World War I tents until the early 1930s, when cabins were built. Here the boys pause after finishing dinner in the pavilion. (Courtesy of Herbert Lorenz Estate.)

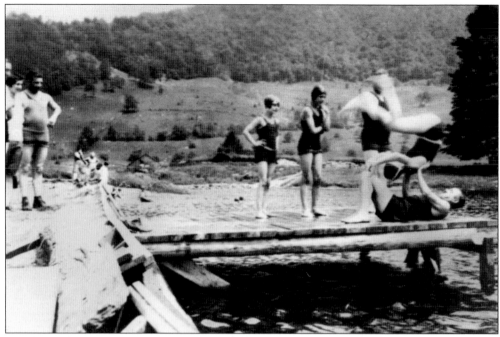

Family members of Verdmont, a private residence area along Old Military Road, play in the waters of Thompson Pond in this view from the 1920s. The pond served as an ice pond when the farm was worked. Early in the 20th century, the camps at Verdmont were occupied by families on a part-time basis. Hunting and fishing were two of the primary reasons why people wanted to live at Verdmont. (Courtesy of Ann Bugbee.)

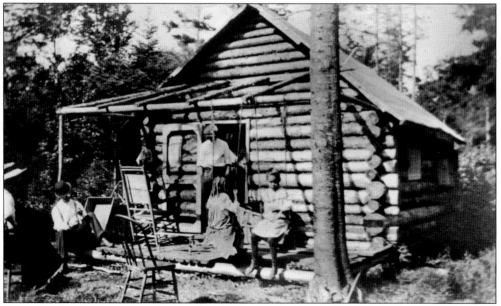

At the Sucker Pond camp of the Knapp family, (from left to right) Mina, Harry, Ralph, Myrtle, and Carrie Knapp relax on swings and chairs. Although Sucker Pond is located in the town of Stamford, it is a popular fishing spot for residents of Pownal as well as Bennington. Sucker Pond is Bennington's major source of water. (Courtesy of Ron Knapp.)

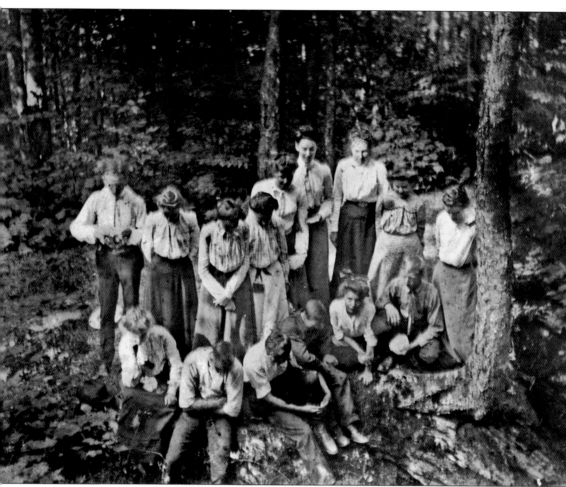

The Snow Hole has long been a popular hiking destination for folks from Pownal. Located near the crest of the Taconic Range and the New York border, the hole's shade preserves snow long into the summer. Here, in 1903, a group of young men and women gather around the hole. Note that some people in the first row are holding snow in their hands. From left to right are (first row) Grace Bishop, Charlie Hicks, Henry Amadon, Karl Hathaway, Louise Wood, and James Plumb; (second row) Walter Niles, Laura Stafford, Grace Percy, Lois Niles, Florence Hicks, Mattie Hicks, Ella Barber, Mildred Hicks, and Jenny Hicks. The photographer is believed to be William Greenslet. (Courtesy of Charlotte Comar.)

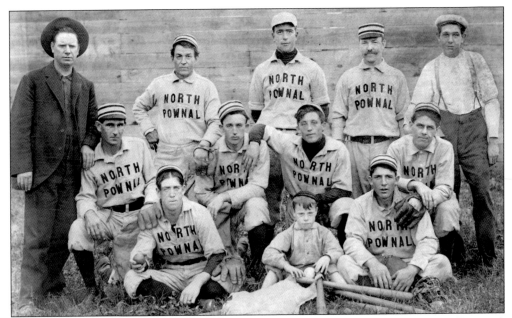

The North Pownal baseball team poses prior to World War I. From left to right are (first row) William Hurley, an unidentified mascot, and Henry Tatro; (second row) Michael Furlong, Arnel Tatro, John Hurley, John Savory, and Fred Andrews; (third row) Albert Curry, ? Gardner, and two unidentified players. (Courtesy of Melba Cooper Estate.)

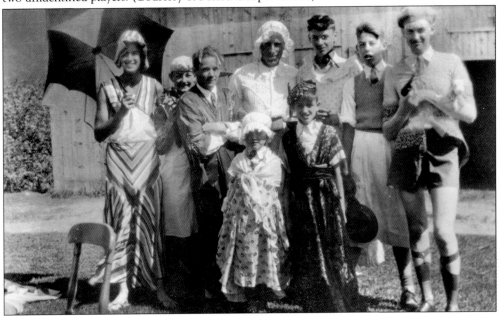

Family and friends gathered on June 7, 1934, to celebrate the 60th wedding anniversary of Eros and Mary Ellen Greenslet Hicks (ages 85 and 81, respectively). Their grandsons and grandsons-in-law performed in costumes of their choice. Pictured from left to right are (first row) Arthur and Donald Hicks; (second row) Mason Amadon, Kenneth Purdy, Alpheus Hoy, Forest Smith, Robert Fowler, Robert Purdy, and Harold Hicks. A grand time was had by all. (Courtesy of Charlotte Comar.)

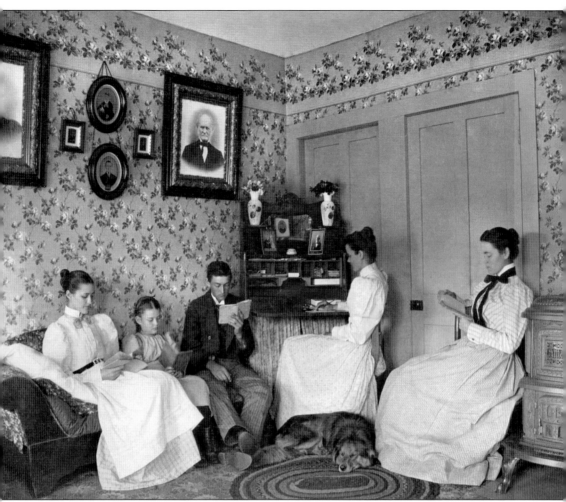

Reading in the parlor of their home on Maple Grove Road around 1900 are, from left to right, Julia Hicks Amadon, Mildred Hicks Crosier, Charles Hicks, Jennie Hicks Fowler, and Martha Hicks. While loyal protector McKinley lies quietly by their feet, Hicks and Greenslet ancestors look down from the wall above. (Courtesy of Charlotte Comar.)

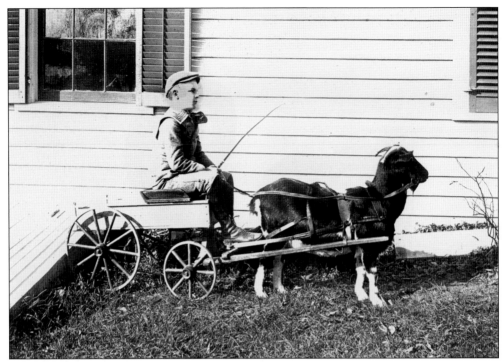

Young Edward Jepson poses in his goat cart. Goat carts became popular during the early part of the 20th century, and they were common subjects for photographers. (Courtesy of Rachel Mason.)

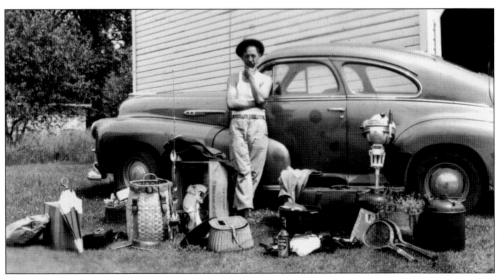

Prior to one of his many fishing expeditions, John Maxmillian ponders how he is going to fit all his fishing gear into his car. In addition to fishing, Maxmillian was a big-game hunter and, thankfully, an avid photographer. (Courtesy of Mary Louise Mason and Julia Maxmillian.)

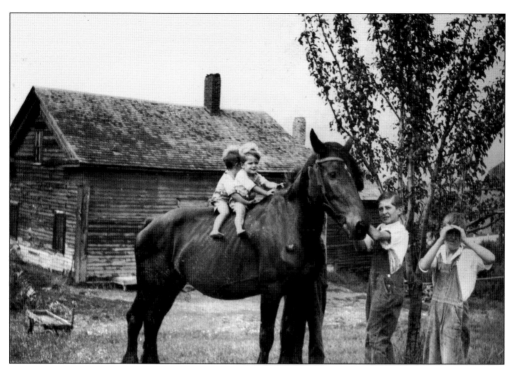

In the early 1930s, Joel Burrington (left) and Bruce Burrington ride bareback on top of a horse with Walter Jr. and Abe Morgan in front, while Walter Sr. hides in the back. Over the years, the Burrington family owned several different farms. (Courtesy of Karen Burrington.)

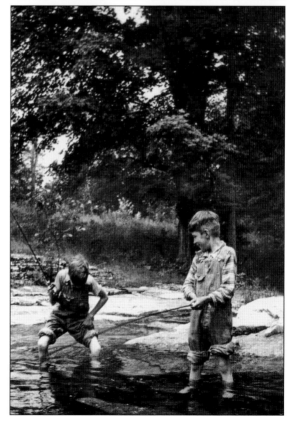

Twins Joel Burrington (left) and Bruce Burrington take some time out from helping on the farm to try their hand at catching fish for supper. (Courtesy of Karen Burrington.)

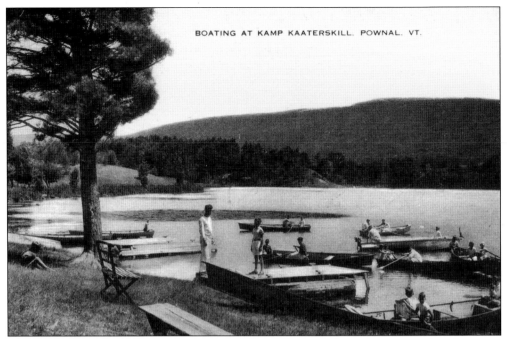

With the east mountain in the background, Kamp Kaaterskill youths prepare for a lesson in rowing on Barber Pond. Below, Kamp Kaaterskill boys row their boats across Barber Pond to the raft secured near the outlet of the lake, where the water overflows under Barber Pond Road. After Kamp Kaaterskill closed in 1944, Friday night dances, school picnics, and other functions were held in the pavilion, which was then owned by the Barber family. All that remains of the pavilion today are two stone fireplaces. (Both, courtesy of Herbert Lorenz Estate.)

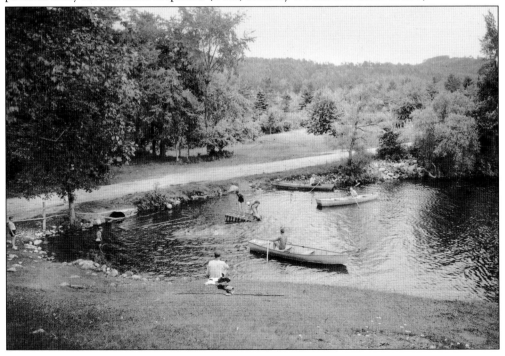

Riding with her friend Mamie Mason, who lived in East Pownal, Susie B. Robinson stopped to let her horse have a drink at the horse trough on the road from Pownal to Bennington, now Route 7. Mason decided to take a drink herself, so Robinson photographed her. (Courtesy of Joy Mason Bull.)

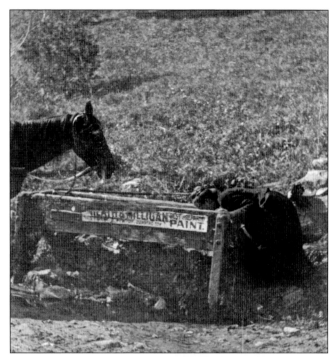

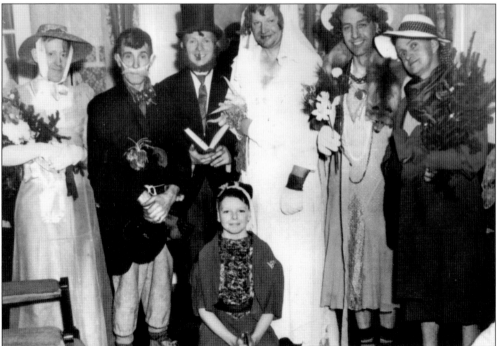

Mock weddings, such as this one in 1940 at the home of Charles and Gladys Mason, were popular entertainment at anniversary celebrations. As indicated in this photograph, men often dressed the part of women. Standing, from left to right, are Harry Beals Sr., George A. Pratt, Charles Mason, Phillip Pratt, John Maxmillian, and Dan Mason. Sitting in front is Anson "Sonny" Pratt. (Courtesy of Anson Pratt.)

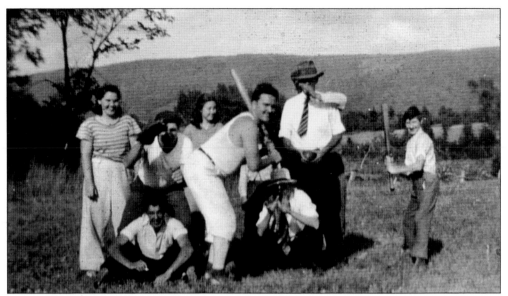

Ray Crosier is about to swing the bat at this 1930s Crosier family reunion. Other players are, from left to right, Belle Crosier, Frank Hollister (on ground), Walter Crosier, Helen Devlin, Clarence Crosier (catcher), Ralph Mattison, and Vincent Devlin. The two individuals hidden behind the group are unidentified. (Courtesy of Charlotte Comar.)

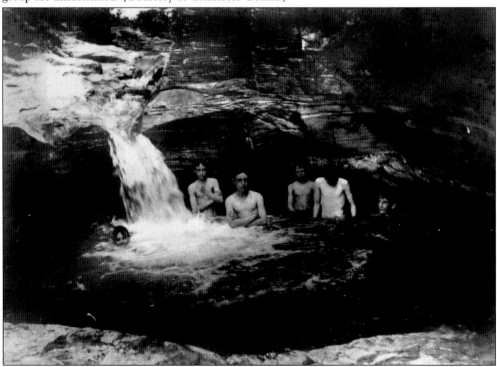

These young people enjoy swimming in the Tubs in North Pownal in the 1930s. Tubs Brook was a popular place for picnics, parties, and relaxing in the cold waters. The tubs were pools carved out of the solid rock by the water rushing down and causing rocks to spin, thereby carving basins, or "tubs," in the limestone ledge. (Courtesy of Melba Cooper Estate.)

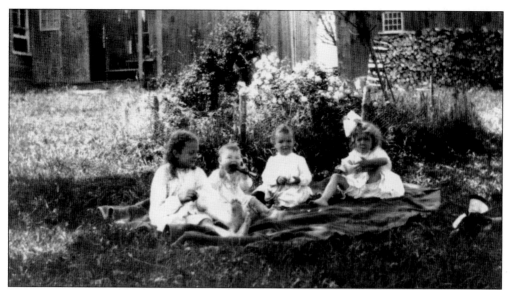

From left to right, cousins Mary Fowler, Robert Purdy, Mason Amadon, and Mildred Purdy enjoy each other's company sitting on a blanket during a summer's day in 1919. Mildred, with the big white bow in her hair, seems to be concerned about her foot, while Mary tries to console her. Note the big pile of wood in the background ready to keep the woodstove burning during the upcoming winter. (Courtesy of Charlotte Comar.)

The Reynolds Carpenter home on Carpenter Hill burned around midnight one night in 1911. Only a few items were salvaged—the portraits of Carpenter and his wife shown in Chapter One, some furniture, and a pewter candlestick. Edgar Holt built this chimney where the old home had been. Here, members of the Holt family and other Carpenter descendants gather to have a picnic and celebrate the new beginning. (Courtesy of Ted Atkinson.)

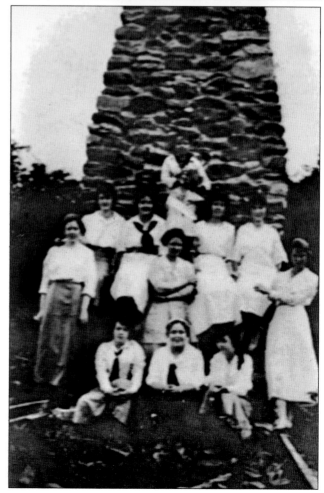

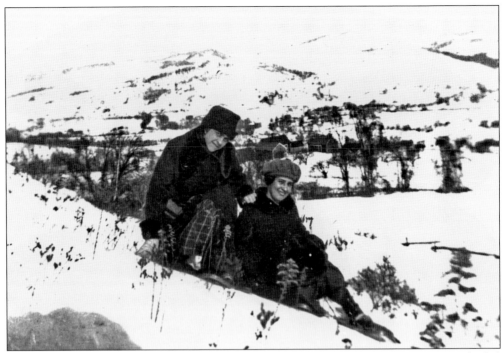

While sliding down Montgomery Hill west of the Hoosic River, Gladys Montgomery (right) and an unidentified friend pause in the snow to pose for the photographer. (Courtesy of Mary Louise Mason.)

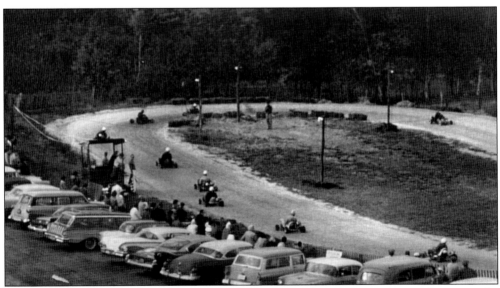

In the summer of 1962, folks in Pownal joined the national craze for go-carts and converted a field owned by Ned Towslee off Barber Pond Road in Pownal Center into a track. Racing was a popular Friday night activity. Today the track is gone, and the field has grown in. (Courtesy of Pam Goodhue.)

Eight

GETTING FROM
HERE TO THERE

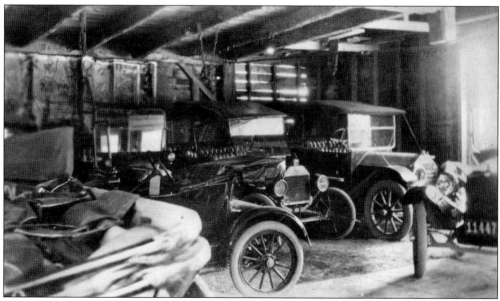

What antique car collector wouldn't love to own this collection of cars stored in Roy Lampman's garage in Pownal Center? Alice Lampman, who photographed the garage, claimed there were eight cars in this picture and asked, "Can you find them?" Lampman's car dealership and garage was housed in a former blacksmith shop next to his home. By the 1940s, Lampman had built a large new dealership and showroom farther north on Center Street. (Courtesy of Frances Lampman.)

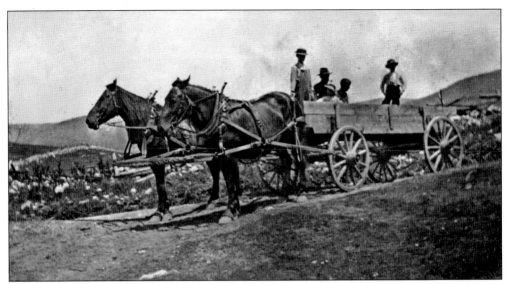

Early transportation was on dirt roads and was provided by horse and wagon. Here members of the Linus Towslee family bring their wagon from the field. Around 50 acres of a Towslee farm was sold to a big manufacturing company about 1900 for iron mining. (Courtesy of Ron Knapp.)

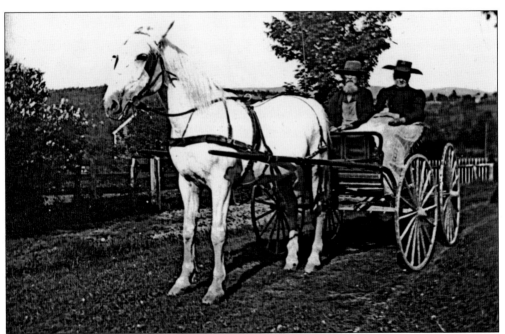

William Montgomery and his wife, Sarah, are out for a ride in their carriage behind Roxy. Buggies or carriages were usually intended for short rides. A horse well trained in pulling a carriage was a valuable animal. Hooking up and unhooking holdbacks, traces, and lines may seem complex these days, but years ago, knowing how to hitch and unhitch a horse was a skill most people needed. (Courtesy of Gary Harbour.)

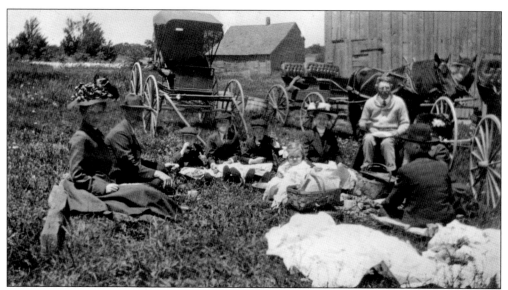

The Towslees, Montgomerys, and Harbours set out in the buggies parked behind them for an extended family picnic dressed in their Sunday best. Many close relationships among Pownal families led to marriages. Today folks tracking genealogies of Pownal families are amazed at how many families intermarried over the years. (Courtesy of Ron Knapp.)

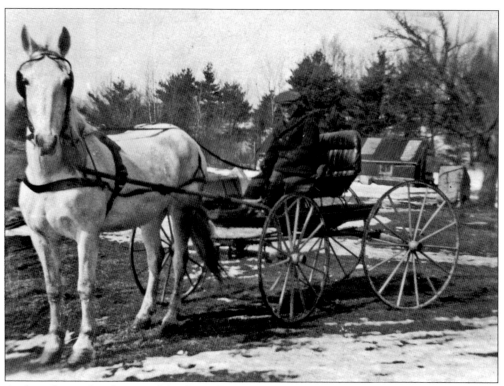

Andrew Crosier heads out with his horse Fanny on a wintry Sunday afternoon to visit neighbors or his future wife, Mildred Hicks, who lived a couple of miles down the road. (Courtesy of Charlotte Comar.)

In the early 1900s, Harry Wilson takes twins Florence and Frances out for a stroll in their baby carriage. Or was it Frances and Florence? Florence Wilson Towslee later served as Pownal's town clerk for 15 years. (Courtesy of Ray Rodrigues.)

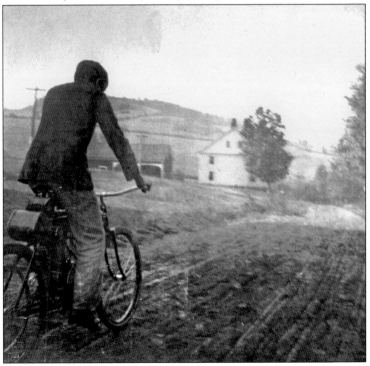

Bicycles were a popular form of transportation, regardless of road conditions. Here Wilfred Keith rides his bicycle down a muddy Center Street in Pownal Center long before the road was paved. (Courtesy of Frances Lampman.)

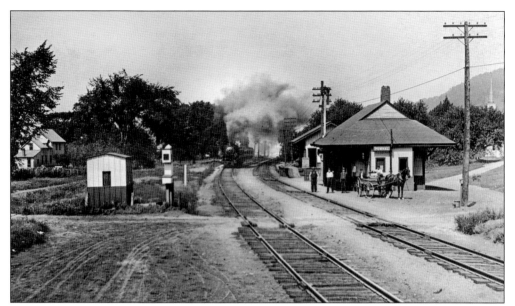

With the advent of the railroad, trains came to Pownal in the mid-19th century. The Troy and Boston Railroad, now Boston and Maine, served Pownal and North Pownal. The Pownal depot was demolished on March 1, 1915, when four freight cars left the tracks. Because the accident happened early in the morning, no one was hurt, but one chicken from the Myers henhouse was killed. (Courtesy of Solomon Wright Public Library.)

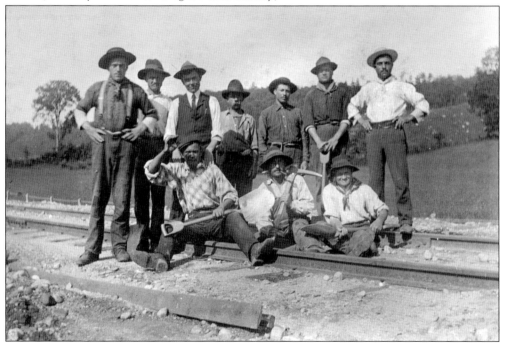

Railroad workers pause from their labors along the tracks through Pownal long enough for the photographer to capture them. In addition to shovels, these laborers also used pole pikes to straighten the railroad ties. At one time, tracks ran along both sides of the river, but those on the west side were later removed. (Courtesy of Ray Rodrigues.)

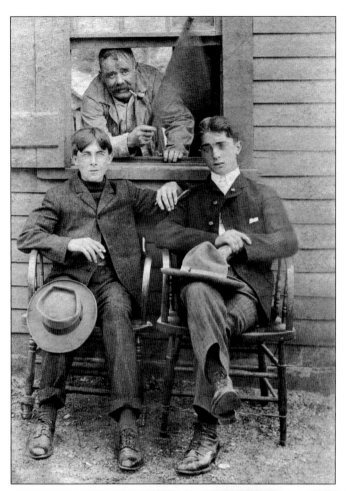

Railroad flagman Pat Kelly leans out the window over two young men sitting outside the North Pownal Railroad Station in the early 1900s, before World War I. (Courtesy of Melba Cooper Estate.)

Below, Flagman Pat Kelly (left) and Sol Towslee prepare to signal the engineer that this particular train is ready to leave the station. The railroads stopped often in both Pownal village and North Pownal delivering travelers who stayed in the local hotels and picking up produce like the huge apple crops that once were grown here. (Courtesy of Ron Knapp.)

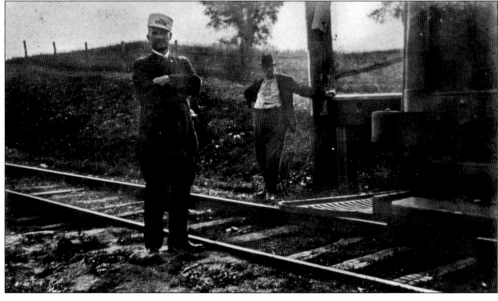

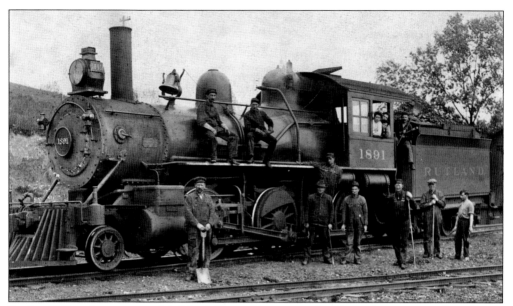

Engine 1891 and crew stopped in North Pownal long enough to have their picture taken. Trains plagued by mechanical and financial problems were sometimes delayed, and with the advent of the motorcar, people rode them less and less. Railroad service to Pownal finally ended in 1950. (Courtesy of Solomon Wright Public Library.)

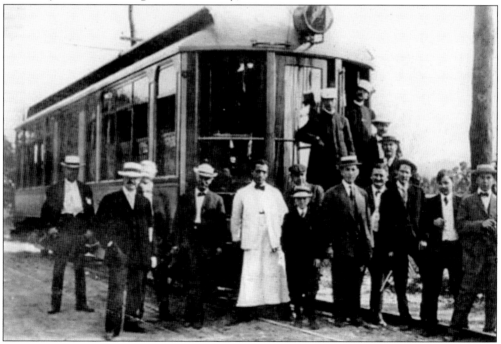

Electric streetcars of the Berkshire Street Railroad connected Bennington to Williamstown, North Adams, and Pittsfield, Massachusetts, passing through Pownal. This first trolley car to cross the state line stopped for a photo op on June 7, 1907. This car, the "Berkshire Hills," was a luxury trolley that cost a bit more to ride. The trip from Bennington to North Adams took a half-hour. (Courtesy of Kinsley Goodrich.)

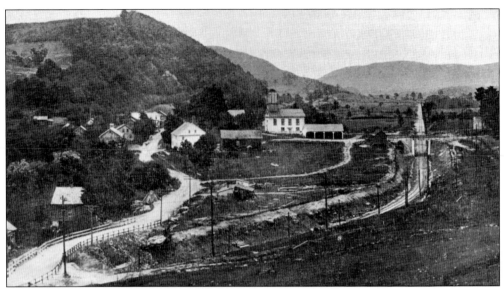

The trolley climbed 5 miles from the valley floor to Pownal Center, which was 958 feet above sea level. The trolley bed was below grade, with bridges above. The trolley provided transportation to jobs and for sightseeing and hauling light baggage, while opening social and business interactions between communities. In the 1960s, the former rail bed would be incorporated into the new U.S. Route 7 highway. (Courtesy of Wendy Hopkins and Ray Rodrigues.)

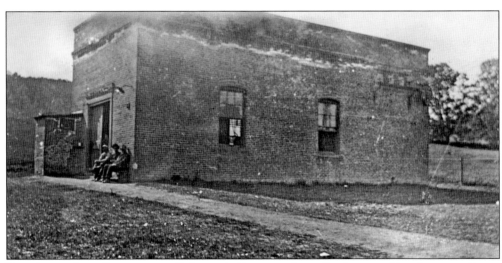

Powerhouses for trolleys were usually located adjacent to the trolley barns and headquarters. Steam power turned the generators that produced the electric energy. The powerhouse in Pownal Center, which still stands at the top of the long incline from the Massachusetts border, was actually a substation used to convert 600 volts AC current to DC and transmit it short distances to operate the cars. (Courtesy of Ron Knapp.)

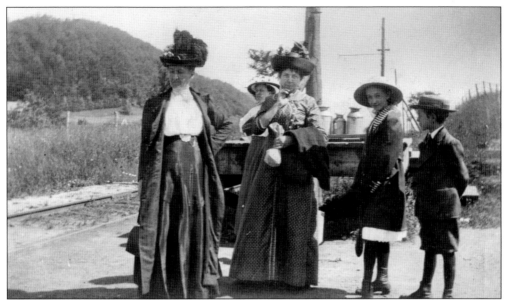

From left to right, Hattie Card, Freelove Amadon, Irene Card, and William Card wait for the trolley to pick them up along with the milk cans behind them. An unidentified woman stands behind the group. A special express car carried perishable foods. By the 1920s, travel by trolley had diminished. The advent of the automobile and a disastrous flood in 1927 would spell the demise of the trolley. Trolley service to Pownal ended in 1927. (Courtesy of Ron Knapp.)

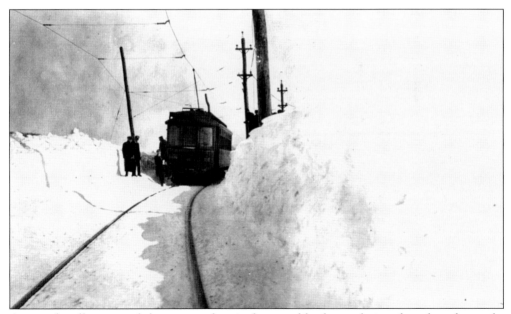

A special trolley car with large snow fans in front and back was designed to clear the tracks during heavy snows. Even then, crews often had to clear parts of the tracks by hand. In this scene, below Pownal Center, the trolley line overlooks the Hoosic valley and the Taconic Mountains. (Courtesy of Kinsley Goodrich.)

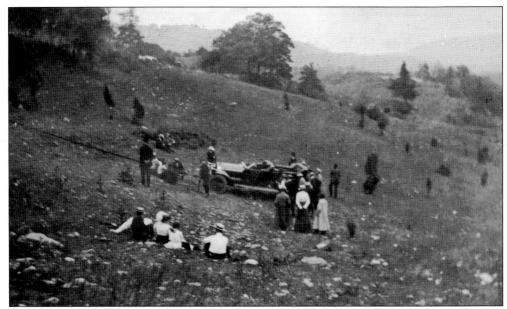

Dirt roads were constantly being improved to accommodate automobiles, but it was not long after cars were introduced to Pownal that accidents occurred. Here, in 1914, a small crowd gathers to watch an automobile being winched up a hill after it left the road and rolled down. (Courtesy of Ron Knapp.)

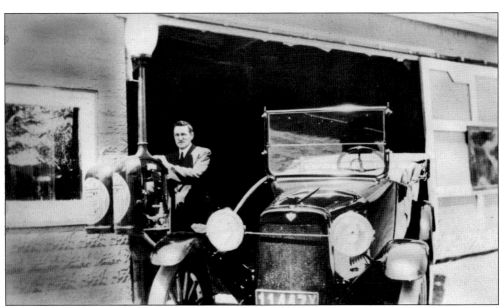

"Fill 'er up, Roy!" That is probably what the photographer said as he captured Roy Lampman pumping gas into this automobile in 1915. Lampman's garage opened around 1914, and a showroom was added in the 1930s. Warren Wire leased the space in the late 1940s to house accounting offices and brought electricity to the space. The electric pole still stands in Frances Lampman's backyard. (Courtesy of Frances Lampman.)

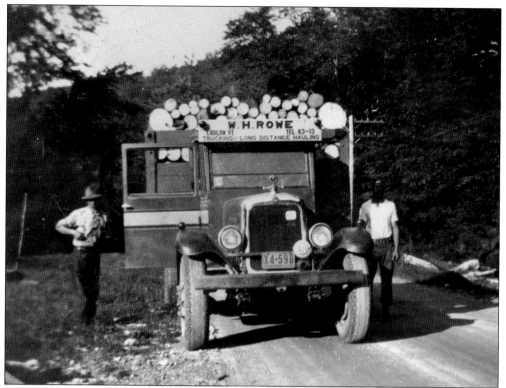

By the 1930s, trucks were also being used for hauling products and materials. In 1930, W. H. Rowe from Ludlow, Vermont, drove down to Pownal to pick up a load of logs from the Proud family. Joe Proud (left), like many farmers, grew crops, raised food animals, and did whatever work they had to as the seasons changed. (Courtesy of Sylvia Proud.)

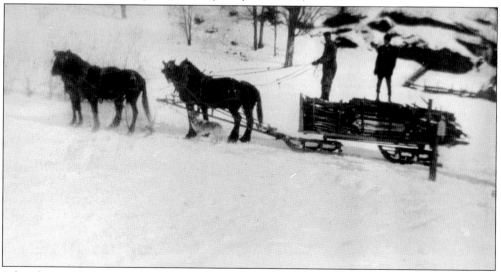

After the men have chopped and sawed many hours in the snow, horses draw a sledge with logs down Carpenter Hill Road to the sawmill. In the mid- to late 1800s, area mills included the McCumber mill on the Hoosic River, the Bushnell and Barber mills on Barber's Pond, and a little farther north, the Othniall Towslee mill on South Stream Road. (Courtesy of Rachel Mason.)

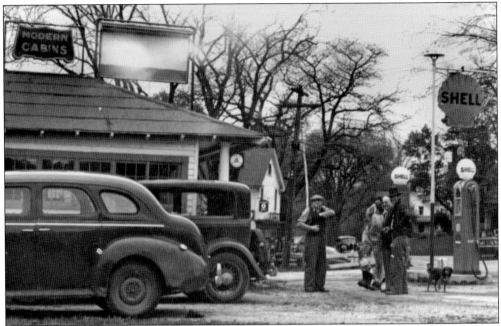

The Ladd Brook Dairy Bar and Gas Station was purchased by Henry and Lillian Bassen and her parents Harry and Gesine Siedenberg in 1946 from Winfred "Nick" and Emma Proud. Here Harry Siedenberg (far left) chews the fat with a couple of Pownal residents by a 1931 Pontiac and a 1940 Nash. The Bassens moved to Pownal from Brooklyn with two cars, five people, two cats, and a dog. (Courtesy of Henry Bassen.)

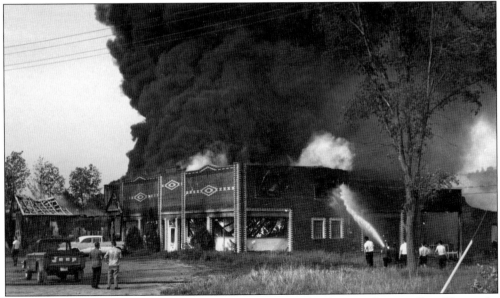

In the 1940s, Lampman built a new dealership on the east side of Center Street, selling Plymouths and Chryslers. The showroom had pink concrete floors, was managed by Clarence Crosier, and eventually was sold to him. When Teflon came into being, the Warren Wire Company rented space in the building for its Plant 3. In 1949, the building was engulfed by flames and burned to the ground. (Courtesy of Pam Goodhue.)

Nine

IN WAR AND PEACE

In September 1958, a ceremony was held on the site of the North Pownal Academy to unveil a bronze plaque recognizing U.S. presidents Chester Allen Arthur and James Garfield, who both taught there in 1851. AnnMarie Pudvar was chosen to unveil the plaque because of her perfect attendance at church Sunday school. Ethel Peckham Haswell of Petersburg, New York, did the background research confirming the presidents teaching there. (Courtesy of Andy Dodge.)

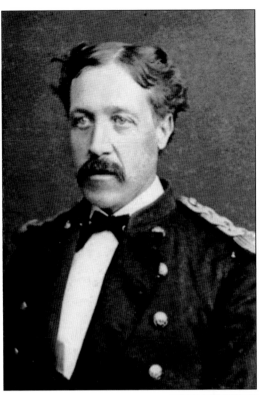

Merritt Barber was born in Pownal on July 31, 1838. He received his early education at North Pownal Academy and graduated from Williams College in 1857. He enlisted in Company E, 10th Vermont Cavalry, and served throughout the Civil War. A career soldier, he retired as a brigadier general of U.S. Volunteers in 1901 to summer in Pownal after a remarkably long and active military career. (Courtesy of Vermont Historical Society.)

John Sumner volunteered as a private under Capt. H. F. Dix of Company F, 16th Vermont Regiment, and served in three principal battles of the Civil War. He was wounded at Gettysburg, after which he received an honorable discharge. Back home in Pownal, Sumner was a tax collector for many years. According to his obituary, Sumner was "well known in Pownal as an honest, thrifty and industrious person." (Courtesy of Gertrude McIver, Sumner's great granddaughter.)

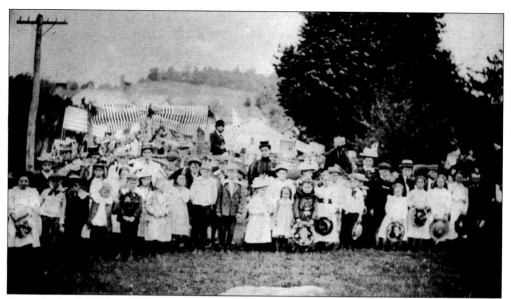

Pownal schoolchildren gather on the green of the Pownal Center Church to celebrate Memorial Day in 1897 or 1898. Two of the teachers in the picture are Myra Wilcox and Kittie Gardner. (Courtesy of Eleanor Wilcox Murphy.)

Joe Proud poses in his World War I uniform for a photographer in Boston. Proud worked for a number of years at Smith's Store in North Pownal and later ran a guesthouse in Pownal village. (Courtesy of Sylvia Proud.)

This photograph of Charlotte Crosier Comar and her kitties was carried through World War II by her older brother Kenneth Purdy and was returned to her after he was killed in action in 1943. Notice the frayed edge of the photograph from being carried in Purdy's wallet. Kenneth was one of five young men from Pownal who gave their lives for their country. (Courtesy of Charlotte Comar.)

Howard "Happy" Lackey sent home this photograph from Nuimfor, Indonesia, in the South Pacific in 1944. Lackey grew up on Maple Grove Road and attended Maple Grove School. After the war, he worked for Ideal Fuels in Bennington delivering fuel and installing fences. (Courtesy of Margaret Lillie.)

In its 1946 *Town Report*, Pownal honored the memory of four young men who gave their lives during World War II: Kenneth Purdy, who died in the Arundel Jungle; Charles Pettibone, who died over Brunswick, Germany; Sterling Sprague Jr., who died in France; and LeRoy Baker, who died in Germany. David Powell was lost and declared dead after the report was published. (Courtesy of Charlotte Comar.)

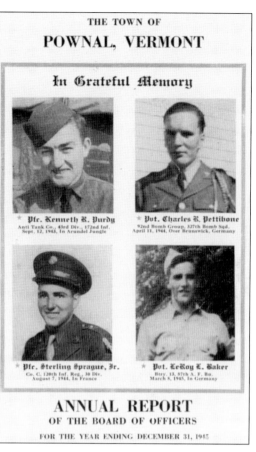

THE TOWN OF

POWNAL, VERMONT

In Grateful Memory

Pfc. Kenneth R. Purdy
Anti Tank Co., 43rd Div., 172nd Inf.
Sept. 12, 1943, In Arundel Jungle

Pvt. Charles R. Pettibone
92nd Bomb Group, 327th Bomb Sqd.
April 11, 1944, Over Brunswick, Germany

Pfc. Sterling Sprague, Jr.
Co. C, 120th Inf. Reg., 30 Div.
August 7, 1944, In France

Pvt. LeRoy L. Baker
Btry. 13, 87th A. F. Bn.
March 8, 1945, In Germany

ANNUAL REPORT
OF THE BOARD OF OFFICERS
FOR THE YEAR ENDING DECEMBER 31, 1945

Margaret Lillie poses in August 1945 as a member of the WAVES (Women Accepted for Volunteer Emergency Service). By serving in the military, Lillie could earn university credit. Lillie took advantage of the opportunity and became a lawyer. As seaman first class, she entered the naval air station control tower school where, she said, "I hardly knew the back from the front of the airplane." (Courtesy of Margaret Lillie.)

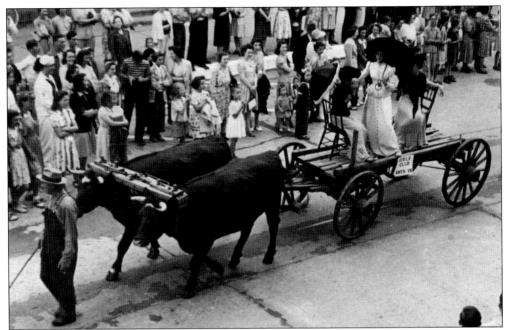

Pownal's Fred Lillie leads his two oxen in the Bennington Memorial Day Parade shortly after World War II. A fifth-generation Vermonter, Lillie was a farmer, ran a sawmill, and made maple syrup. Multi-talented, he was also a builder who worked on the post office in Bennington. While strolling up Monument Avenue, he met his future wife, Winifred. (Courtesy of Margaret Lillie.)

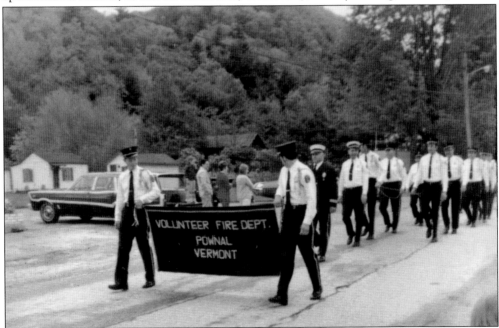

The Memorial Day Parade moved from Pownal Elementary School to the cemetery at Pownal Center in 1971. This was an annual town commemoration for many years. The town still relies on volunteer fire fighters such as these to fight brush fires, search for drowning victims, and give lessons to young children. (Courtesy of Charlotte Comar.)

Pownal joined the national bicentennial celebration by holding a ceremony on the village green recognizing its beginnings. In this picture, the artist who painted the portrait of Gov. Thomas Pownall, Mildred Grey (center), presents the painting to town clerk Rachel Mason while Charles Palmer, town moderator, watches from the bench. Behind them is the addition to the town office that was dedicated during Bicentennial Day ceremonies. (Courtesy of Rachel Mason.)

Historian and Bennington resident Joe Parks signs copies of his book, *Pownal: A Vermont Town's First Two Hundred Years and More*, in 1977. Parks completed what remains the most comprehensive history of Pownal in time for the nation's bicentennial celebration. Many of the photographs provided to him for that book have since been lost. (Courtesy of Rachel Mason.)

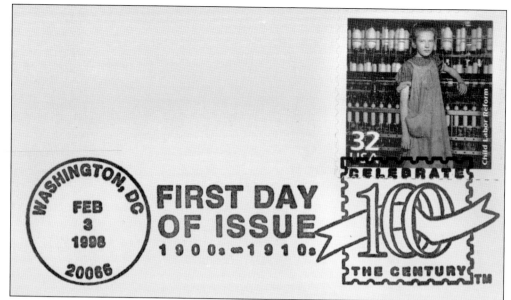

This first-day cover of the Child Labor Reform stamp commemorates the passage of the first federal child labor law in the United States. Lewis Hine's photograph of Addie Card in the North Pownal cotton mill in 1910 helped burn the plight of child workers into the consciences of Americans. The law set the minimum age and hours for children to work in most occupations. (Courtesy of Ray Rodrigues.)

On June 24, 1991, at Green Mountain Race Track, Gov. Richard Snelling (holding one half of the flag) shouted "Wagons Ho" to travelers embarking on the Historic Vermont Bicentennial Heritage Journey Wagon Train. The journey, commemorating the 200th anniversary of Vermont statehood, was an 18-day trek through the state that started in Pownal. Henry and Cecily Strohmaier were active participants and furnished horses for persons wanting to make the trip. (Courtesy of Mary Louise Mason.)

Ten

FRIENDS AND NEIGHBORS

Mary Jane Rounds won the title of Mrs. Vermont in April 1957 by competing in cooking ability, table setting, and floral arrangement. Her chocolate cake put her over the top. She traveled to Florida in 1958 to compete in the national competition. Here she poses at her sewing machine at the Beach Club Hotel in Fort Lauderdale while her husband, Charles "Chug," relaxes and shows his approval. As Mrs. Vermont, Rounds also promoted the sale of U.S. Savings Bonds. (Courtesy of Mary Jane Rounds.)

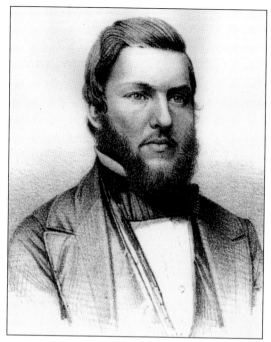

The young James Garfield is shown in this engraving from the archives at Williams College. By unique coincidence, Garfield and Chester Arthur, future U.S. presidents, both taught school in North Pownal in 1851, in succession, at the beginning of their careers. Garfield became president in 1880 with Arthur as his vice president. When Garfield was assassinated in 1881, Arthur succeeded him as president. (Courtesy of Williams College Archives.)

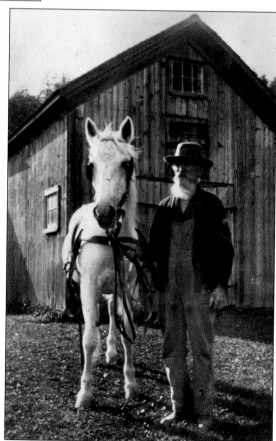

William Montgomery, seen here with his horse, Roxy, served in the Civil War and was a soldier in a troop assigned to protect Abraham Lincoln. The family history indicates that he was outside Ford's Theatre in Washington, D.C., the night Lincoln was assassinated. (Courtesy of Gary Harbour.)

Five generations of Lampmans gathered in front of their home in Pownal Center in 1915. A remarkable feature of family history is that all, from great-great-grandmother to great-great-grandson, were born in Pownal and passed their entire lives here. They are (seated) Mrs. Ann M. Towslee, 88; and Mrs. Mary Frances Lampman, 69; (standing) Julia Wilson, 45; Harry M. Wilson, 26; and Harold M. Wilson, 15 months. (Courtesy of Frances Lampman.)

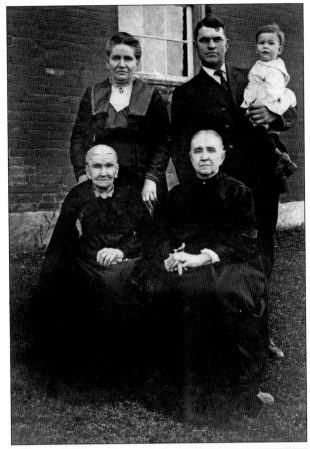

Below, Othniall Towslee and Ann Bushnell Towslee sit for their portraits in the 1860s. They were both born in Pownal and lived in East Pownal, where Othniall owned a sawmill, gristmill, and bobbin mill on South Stream Pond. After Othniall died, Ann moved into the home of her daughter, Mary Frances Towslee Kimball. (Courtesy of Frances Lampman.)

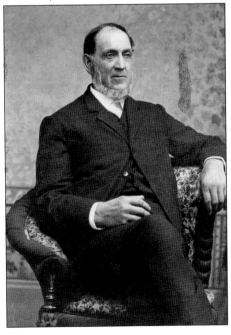

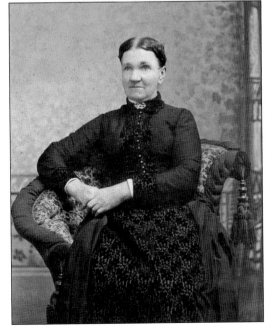

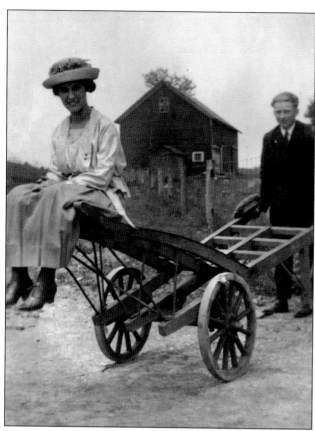

Dressed in their best bib and tucker, Charlie Mason courted his future wife, Gladys, by giving her a ride on this railroad baggage cart. Charlie was Pownal's town moderator for many years, starting in 1935. Gladys taught school in Williamstown, Massachusetts, for more than 40 years. Descendants of Gladys believe that, in later years, Gladys would not have approved of this picture. (Courtesy of Mary Louise Mason.)

Laura Pratt, the oldest child of Henry and Hattie Pratt, was educated in Williamstown schools. Here she is being driven by her brother Anson to North Adams Normal School, later North Adams State College and now Massachusetts College of Liberal Arts. Laura became a teacher and married Harry W. Beals Sr. They had five children. (Courtesy of Betsy Beals.)

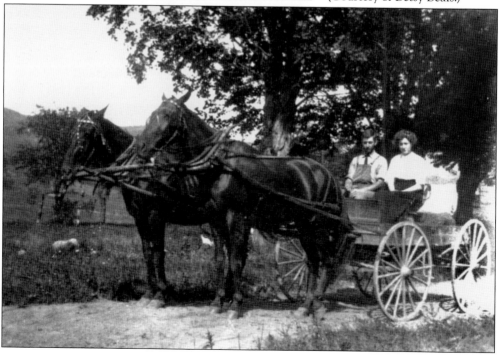

Clara Estes Jepson, a well-known psychic, attributed her powers of clairvoyant vision to her one blue eye (the other was brown). She was best known for finding lost objects. Her method of divination was to make pencil markings on the folds of a handkerchief, always provided by the person looking for information. Born in 1861 in Adams, Massachusetts, she died in Pownal in 1948. (Courtesy of Julia Maxmillian.)

The women on the Fowler farm on Carpenter Hill are shown here in 1919. From left to right are Rachel Mason's mother, Jenny Hicks Fowler; Jenny's daughter Mary; grandmother Alice Fowler; baby Rachel; and young Robert. Rachel became town clerk in 1955 and served for 35 years. Robert became a successful farmer, while Mary married and moved away. (Courtesy of Rachel Mason.)

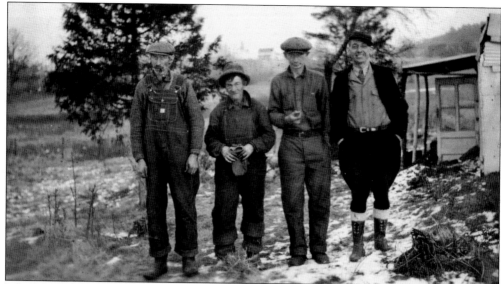

John Maxmillian (far right) stands with the Rood brothers, (from left to right) Arthur "Tater," Wesley "Wes," and Abraham "Abe." The three brothers lived with their mother in a little house in the meadow below the Peckham farm in Pownal Center. Related to several old Pownal families, they hired out for various farm tasks and were well known and liked by the people in the area. None of them married. (Courtesy of Julia Maxmillian.)

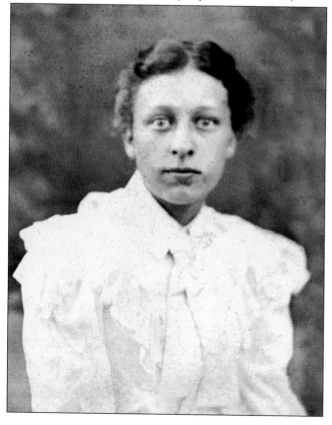

Six-foot-tall Eunice Dean Burrington (1882–1971) farmed, made bread, canned vegetables, mended clothes, fed hired hands, raised two children, and drove teams of horses. Once, after arguing with her husband, Marcus, she dumped a pail of sour milk on him. After her son Walter's family declined her Thanksgiving invitation, Eunice never spoke to them again. She willed her farm to the University of Vermont. (Courtesy of Georgene Burrington Villanueva.)

Julia Barber Maxmillian poses quietly with Howard Black's horse while her husband, John, snaps the picture. John worked for Maxymillian Construction and was also a big-game hunter and fisherman. They traveled to Alaska and many other beautiful places, bringing back many photographs to share with their friends. Julia was distantly related to Noel Barber, Pownal's renowned covered bridge designer. (Courtesy of Jim Therrien.)

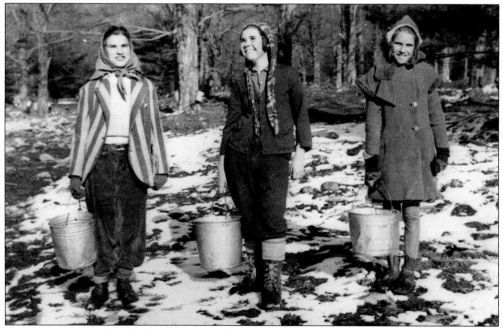

From left to right, Ellen Lillie, Margaret Lillie, and Winifred Lillie help their father, Fred, carry buckets of sap to the sugarhouse to be boiled down into maple syrup. Fred Lillie, a fifth-generation Vermonter, also ran a sawmill. Ellen later worked for the Red Cross, Margaret became a lawyer, and Winifred became a nurse. (Courtesy of Margaret Lillie.)

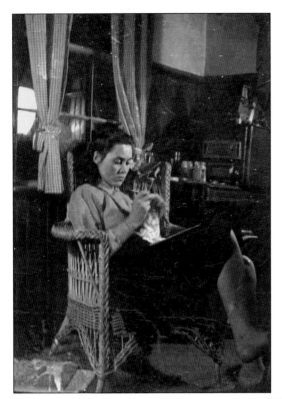

Lura Brown works intently at her crocheting in her parents' home in East Pownal. Lura was town clerk for one year, 1953–1954, and later served as health officer from 1982 to 1993. Her husband, David Adler, was a longtime Pownal school director. (Courtesy Rosemary Brown Estate.)

Marcia Campbell (left) and Edith Sumner check their hems and shoes. Marcia grew up on Barber Pond Road. Her father, William "Willy" Lowell Campbell, was road commissioner during World War I. Edith, aunt of Gertrude McIver, became a teacher, married, and moved to Whitehall, New York, where she raised her two sons and daughter. (Courtesy of Ron Knapp.)

Ellis Maxon was a longtime mail carrier in Pownal in the late 1930s and early 1940s. Here he stands in the snow with his mailbag under his arm. If it had not been for John Maxmillian, who took this image, many photographs of Pownal friends and neighbors would not exist today. (Courtesy of Mary Louise Mason and Julia Maxmillian.)

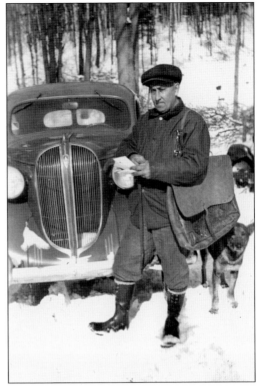

Simeon Crawford, scythe in hand, was the caretaker at Oak Hill Cemetery for many years. Although Oak Hill's cornerstone is dated 1874, some of the gravestones show earlier dates, as bodies and stones were moved from the Lovett yard (near the Green Mountain Race Track) when the railroad was built through it. Oak Hill Cemetery continues to be used today. (Courtesy of Mary Louise Mason and Julia Maxmillian.)

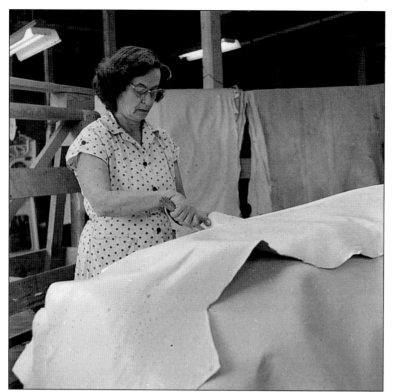

Mildred Hoyt is shown here working at the tannery in North Pownal, trimming the hides of flaws and rough edges. Before she received them, the hides had been stretched, colored, coated, softened, milled, and given special treatments like waterproofing or printing to imitate hair cells. People in the tannery were friendly and watched out for one another, and management was very considerate. (Courtesy of the *Bennington Banner*.)

Twins Florence and Frances Wilson grew up on Mount Anthony Road and pose here upon their graduation from Bennington High School. They lived with their aunt and uncle, Alice and Roy Lampman, during the week so that they could take the trolley to school. Florence served as Pownal's town clerk from 1935 to 1950. The reader needs to decide which is Florence and which Frances. (Courtesy of Frances Lampman.)

Vincent Pizzano rides his sulky led by Double Brewer near his home on Mount Anthony Road in 1959. His daughter Ann is on the donkey Pedro. A contractor and businessman, Pizzano raced his sulky at Green Mountain Race Track in the 1960s and 1970s. (Courtesy of Dorothy Pizzano.)

The town meeting, a time-honored Vermont tradition of civic engagement, was held in the basement of the Pownal Center Community Church until 1991. Among those gathered in 1961 are the two Harry Beals, Richard Pudvar, Fred Lillie, and Ernie Wilcox. Others are not identified. (Courtesy of Rachel Mason.)

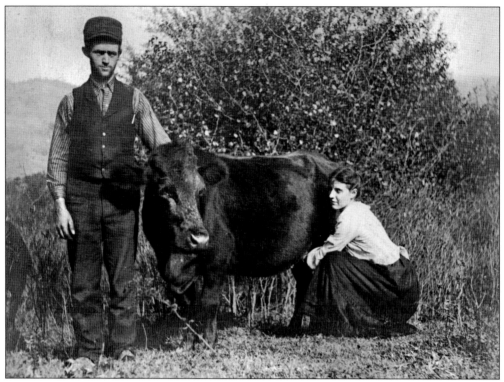

When Susie B. Robinson visited her friends John and Mamie Mason on their farm in 1902, she took many pictures, including several with the Masons' dog Captain. Like all tourists, she had to have her own picture taken to show her friends back home. So here she is with John Mason and his cow Daisy. (Courtesy of Joy Mason Bull.)

Grace Stoddard Greylock Niles published two major books about Pownal: *Bog-Trotting for Orchids* (1904) and *The Hoosac Valley—Its Legends and History* (1912). Her pioneering work in botany and the passion, imagination, and detail of her writing have attracted researchers to her fascinating and somewhat eccentric life. The area where she lived is encompassed by a land conservancy with public hiking trails. (Courtesy of Maida Goodwin and Allison Bell.)

SELECTED BIBLIOGRAPHY

Beers, F. W. *Atlas of Bennington County, Vermont*. New York: F. W. Beers, 1869. Rutland, VT: Charles E. Tuttle, 1971 (reprint).

Brown, William Bradford. *Sketches of Pownal*. Provided by Martha Rudd, 2004. www.rootsweb.ancestry.com/~vermont/LorePownal.html (October 22, 2009).

Chamberlain, Samuel H. and Donal H. Moffat. *Fair Is Our Land*. New York: Hastings House, 1942.

Child, Hamilton. *Child's Bennington County Directory 1880–81*. Syracuse, NY: Hamilton Child, 1880.

Manning, Joseph. *Mornings on Maple Street*. 2007. www.morningsonmaplestreet.com/addiesearch1.html (October 22, 2009).

Niles, Grace Greylock. *Bog-Trotting for Orchids*. New York: The Knickerbocker Press, 1904.

———. *The Hoosac Valley—Its Legends and History*. New York: The Knickerbocker Press, 1912. Berwyn Heights, MD: Heritage Books, 2002.

Parks, Joseph. *Pownal—A Vermont Town's Two Hundred Years and More*. Pownal, VT: The Pownal Bicentennial Committee, 1977.

Perkins, Nathan. *A Narrative of a Tour through the State of Vermont*. Woodstock, VT: The Elm Tree Press, 1920.

Rolando, Victor. *200 Years of Soot and Sweat: The History and Archeology of Vermont's Iron, Charcoal, and Lime Industries*. Manchester, VT: Vermont Archeological Society, 1992.

Rodrigues, Raymond J. *Memoir of a Green Mountain Boy*. New York: iUniverse, 2007.

Winthrop, Elizabeth. *Counting on Grace*. New York: Wendy Lamb Books, 2006.

www.arcadiapublishing.com

Discover books about the town where you grew up, the cities where your friends and families live, the town where your parents met, or even that retirement spot you've been dreaming about. Our Web site provides history lovers with exclusive deals, advanced notification about new titles, e-mail alerts of author events, and much more.

Find Your Place in History.